Magritte

Magritte

Richard Calvocoressi

Phaidon · Oxford

Phaidon Press Limited, Littlegate House, St Ebbe's Street, Oxford OX1 1SQ

First published 1979
This edition, revised and enlarged, first published 1984
© 1984 Phaidon Press Limited

British Library Cataloguing in Publication Data

Calvocoressi, Richard
 Magritte
 1. Magritte, René 2. Painters—Belgium —
 Biography
 I. Title
 759.9493 ND673.M35

 ISBN 0-7148-2274-4
 ISBN 0-7148-2275-2 Pbk

Typeset, printed and bound in Singapore, under co-ordination by
GnP Consultants Private Limited.

The author wishes to thank David Sylvester of the Menil Foundation,
London, for his helpful suggestions.

The author and publishers would like to thank Mme Georgette
Magritte, The Centre Georges Pompidou, Paris, The Tate Gallery,
London, and all those museum authorities and private owners who have
kindly allowed works in their possession to be reproduced.
 They have endeavoured to credit all known persons holding copyright
or reproduction rights for the illustrations in this book. The works of
Magritte, Man Ray and Miró are © A.D.A.G.P. Paris 1984, those of
Atget, de Chirico, Le Corbusier, Dali, Ernst and Léger are ©
S.P.A.D.E.M. Paris 1983.
 Thanks are also due for permission to reproduce the following photo-
graphs: Plates 15, 16, 19, 24, 44, 45, 46 by courtesy of the Arts Council of
Great Britain, London; Figs. 31, 41 by courtesy of Christie's, London;
Fig. 4 by courtesy of the National Film Archive/Stills Library, London;
Figs. 1, 2, 10, 14, 16–20, 22–4, 26, 29, 30, 32, 33, 35–9, the Tate Gallery
Library, London; Plates 17, 18, 21, 23, 34, 36 © Archives SNARK. The
publishers are also grateful to Mr Gordon Roberton of A.C. Cooper
(Colour Photographers) Ltd.

Magritte

Few people would deny that, of the many artists who participated in that readjustment of our sensibilities which called itself Surrealism, René Magritte remains today one of the most accessible. His paintings speak to us very directly. The great nineteenth-century French painter Gustave Courbet once said that he could not paint an angel because he had never seen one, and there is a sense in which this claim might also have been made by Magritte. (He actually admitted once that 'A woman's body floating above a city was an advantageous substitute for the angels that never presented themselves to my sight.') While other Surrealists painted angels, or more often devils, of their own invention, Magritte stuck closely to what he could see — the real world that we think we know but which, according to him, we do not know at all.

In many ways Surrealism was heir to the great nineteenth-century movements of Romanticism and Symbolism; it took the nineteenth-century protest against rationalism and materialism onto a different level but it was essentially the same protest. The Surrealists' search for the marvellous and their attempts to free the creative imagination from personal inhibition and social constraint were not new but they were given a new, twentieth-century emphasis and sense of urgency. And yet to explain Magritte's achievement simply in these terms is to misrepresent it. His position within the Surrealist movement as a whole was an ambiguous one. His relations with other members of the group, particularly André Breton, its high priest, were not always good. As an artist, he chose to ignore those esoteric phenomena that so excited his colleagues in Paris: neolithic and primitive art, the art of children and of the insane, medieval and symbolist painting, spiritualism, alchemical literature, psychoanalysis — with the exception of the latter, none of these imaginative stimuli made much visible impact upon his painting. To look at a picture by Ernst or Miró or Dalí is to be made aware of private fantasies at work, of rich and complex layers of meaning. Not so with Magritte. Any attempt to read his images as symbols of unconscious fears or repressed desires he firmly resisted. Although his early Surrealist paintings remind us strongly of the irrationalities of the dream world, a large proportion of his art appeals to our conscious mind. Magritte's statements about the world are often in the form of unanswerable questions or riddles, whose purpose may be to upset us but whose apparent logic we find it difficult to deny.

Magritte was not interested in accidental effects, automatism or other typically Surrealist techniques but, in his own words, in 'an objective representation of objects' — so objective, in fact, that his manner of representing them was deliberately prosaic. The Surrealists professed a common hatred of aestheticism and *belle peinture*, but it is in Magritte's cool, straightforward style, derived in part from his admiration for the paintings of the Italian Giorgio de Chirico (1888–1978) but also perhaps from his own work in advertising and publicity, that we find best exemplified this concern that the image should speak for itself, with as little interference from the artist as possible. Because they saw themselves as dealing with elemental experience — a kind of Jungian 'collective unconscious' — the Surrealists believed that their art would speak directly to a large audience, overriding cultural and aesthetic prejudice. By remaining aloof from the Surrealist preoccupation with the stream of consciousness, Magritte went further than his fellow artists towards realizing the ideal of a universal pictorial language — an ideal which in the final analysis is probably unattainable.

If in his art Magritte self-consciously set about to eliminate all traces of his personality, he certainly did not compensate for this in his life. Outwardly uneventful, it exhibited none of the noise and controversy that surrounded the activities of some of his Surrealist friends. Magritte preferred to live a life of bourgeois seclusion and anonymity. The romantic notion of the artist as outsider meant nothing to him: he was a man who painted pictures because he had to earn a living, although in later years he became obsessed by painting. He loved classical music (condemned by Breton for its formalism and inability to disrupt habitual modes of perception), read widely, from philosophy to detective novels and mystery stories (an enthusiasm he shared with some, but not all, of the Surrealists), was an avid cinema-goer but otherwise had few tastes or preferences (except, as we shall see, for certain types of popular art). As far as we know he did not collect exotic objects or artefacts. In

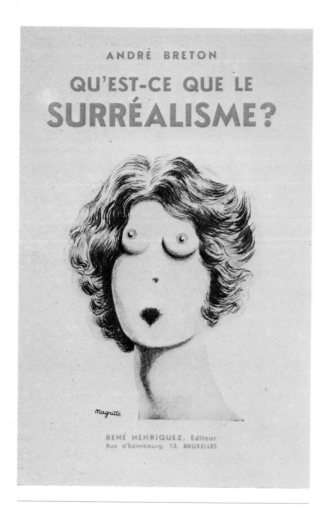

Fig. 1
Cover for 'What is Surrealism?' ('Qu'est-ce que le
Surréalisme?') by André Breton
BRUSSELS, 1934

both art and life he kept a low profile, eschewing the colourful and highly charged, an ostensibly dispassionate observer. 'Ostensibly', because Magritte's self-effacement was a mask which concealed an intensely subversive temperament, an urge to challenge our preconceived ideas about reality, to break our habits of thought and behaviour and force us into a new and heightened awareness of our surroundings. Underneath the harmless-looking uniform of bowler hat and dark suit, the artist prepares to administer a severe blow to our expectations. That kick in the groin, as it were, is made all the sharper by the bland,

literal way in which Magritte's images are presented: his style, like his signature, gives nothing away. This paradox is of fundamental importance to the art of the Absurd, into which category Magritte can with justification be fitted: we have only to think, for example, of the deadpan way in which alarming but unexplained incidents or feelings are expressed in the work of Kafka, Ionesco and Pinter, or even in the films of Buster Keaton, which Magritte enjoyed watching.

Although Magritte's painting is usually described as realistic or 'veristic', it shares certain characteristics with the more explicitly 'poetic' kind of Surrealism: namely, a procedure by metaphor or analogy. In his book *What is Surrealism?*, first published in Brussels in 1934 with, significantly, a drawing from Magritte's *Rape* series adorning its cover (Fig. 1), Breton claimed that Surrealism had done away with simile, with the word 'like': 'a tomato is also a child's balloon'. Simultaneous or interchangeable images occur regularly in Magritte's paintings, coupled with a frequent use of dislocation — the removal of an object from its normal place or context and its introduction into an unfamiliar environment. Anatomical transpositions such as we find in *The Rape* (Plate 35) or *The Spoiler*, which was reproduced on the cover of the *Bulletin International du Surréalisme* for August 1935 (Fig. 2), represent an extreme and brutal example of this practice, in which the ambiguity of the image reaches neurotic proportions. Possibly the most Freudian of all such works is the Tate Gallery's small gouache *The Spirit of Geometry* (originally called *Maternity*; Fig. 3), where the heads of a baby and its mother are interchanged to scale.

The irrational combination of objects, which was a popular device with the Surrealist painters, stemmed from de Chirico, but the Surrealists were also in the habit of quoting a specific instance from one of their favourite authors, the Symbolist Isidore Ducasse (known as the Comte de Lautréamont), writer of nightmarish prose and verse: 'as beautiful as the chance encounter of a sewing-machine and an umbrella on a dissecting table'. The violence implicit in that image, together with its latent sexual content, epitomizes that *frisson* experienced by Breton when reading Symbolist and Decadent literature — a quality he called 'convulsive beauty' and which he recognized as being essential to the Surrealist image. Magritte spoke of his 'determination to make the

most familiar objects scream aloud': the more familiar the object, the louder it would scream when divorced from its habitat, seen in a new light. The artist Marcel Duchamp had already shown how a manufactured object of daily use — bottlerack, comb, coat-hook — could assume a magical and sometimes threatening significance when raised to the level of a cult object or work of art; but his attitude to such standardized objects was supposedly one of complete aesthetic indifference, whereas Magritte's interest, as we shall see, was more positive. A glance at the formative years of his career (a word he would have disliked) reveals a quite different background from that of most other artists who became Surrealists.

René Magritte was born at Lessines, in the province of Hainaut, a French-speaking region of Belgium, on 21 November 1898. His brother Raymond was born in 1900 and their younger brother Paul two years afterwards in 1902. Paul Magritte turned out to be the musical member of the family; when he was eighteen he took piano lessons from E. L. T. Mesens, an admirer of Erik Satie. Mesens, a year younger than his pupil, was a remarkably versatile man who soon became one of René Magritte's closest friends. Poet, composer, Dada collagist and joker, he later worked as an art dealer and publisher. In 1923 he gave up music and a couple of years later, with Magritte and the poet Paul Nougé, formed the nucleus of the Belgian Surrealist movement — a movement that was always to keep a certain distance from the doctrinaire pronouncements of Breton in Paris, and which had a style and flavour unmistakably its own.

Magritte retained an interest in music throughout his life. One of his earliest surviving works (1920) is a portrait of a man playing the violin, and musical instruments, or decorative shapes connected with them such as scrolls and volutes, are common images in his paintings. More significant than this, however, is a group of collages executed in 1926, probably under Mesens's influence, while the two men were collaborating on the proto-Surrealist magazine *Marie*. These collages contain fragments of musical scores, many of them cut out to form a baluster, a recurrent motif in Magritte's paintings from 1926 onwards, which has sometimes anthropomorphic, sometimes phallic connotations, and at other times is simply what it appears to be — an ordinary mass-produced object detached from its natural surround-

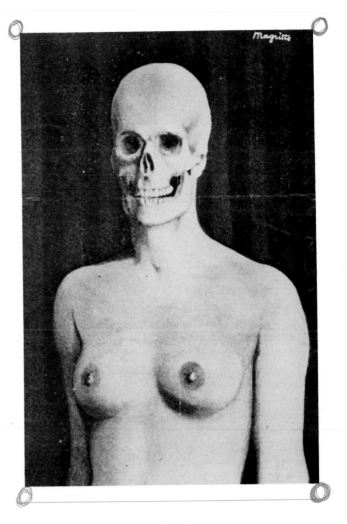

Fig. 2
Detail from the Cover for 'Bulletin International du Surréalisme', no. 3
BRUSSELS, AUGUST 1935

ings (in this case, a row of identical balusters). During the 1930s Magritte designed several sheet-music covers, including one for his brother Paul (*Marie Trombone Chapeau Buse*, 1936).

Magritte was never very forthcoming about his early life — we have to rely on one or two cryptic autobiographical sketches and the often imprecise reminiscences of friends and relations — and a degree of confusion surrounds his parents. We know that before her marriage Magritte's mother had worked as a milliner, but there is less certainty about the occupation of his father Léopold, who seems to have

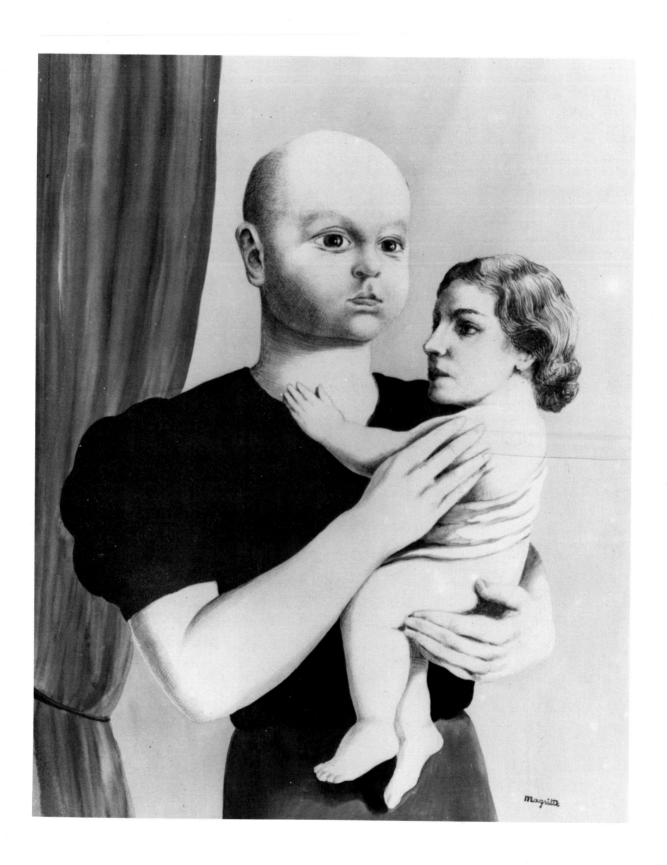

been some kind of manufacturer and trader in provisions. The family was comfortably off and moved around a good deal after Magritte's birth: from Lessines to Gilly, thence to Châtelet, Charleroi and back to Châtelet, before finally settling in Brussels in 1918. Part of Magritte's school holidays was spent with his grandmother and an aunt at the town of Soignies. It was there, while playing one day with a small girl in an abandoned cemetery, that he first became aware of painting as a special and somehow mysterious activity: 'We used to lift up the iron gates and go down into the underground vaults. Regaining the light again . . . I found, in the middle of some broken stone columns and heaped-up leaves, a painter who had come from the capital, and who seemed to me to be performing magic.'

The other crucial event of Magritte's childhood was the suicide of his neurasthenic mother, whose body was retrieved from the River Sambre on the morning of 12 March 1912. For many years it was thought that the face of the suicide had been found shrouded in her nightdress and that, when uncovered, it had worn an expression of calm beauty; it was also alleged that the thirteen-year-old Magritte had been present at the moment of discovery. Recent research has proved beyond doubt that such 'facts' form part of a legend probably fabricated by the Magritte family nurse. What matters, however, is that Magritte was affected by the story of the nightdress: the image stuck in his unconscious and appears to have resurfaced in certain of his paintings where images of cover or concealment play a prominent role. Arguably the most sinister in this category are those paintings that depict the human head entirely swathed in fabric, such as *The Heart of the Matter* (Plate 19) and *The Lovers* (Plate 23). Magritte's ability to convey abnormal physical or psychological states — claustrophobia, anxiety, panic (for example, *The Hunters at the Edge of Night*, Plate 22) — is one of the most distinctive and original features of his art. Less immediately alarming but possibly also traceable to the fictive account of his childhood bereavement are the occasional references in his work to the serene composure of death, of which the several versions of

Fig. 3
The Spirit of Geometry

GOUACHE ON PAPER, 37.5 × 29 CM. C.1936. LONDON, TATE GALLERY

Memory (Plate 41) are among the most haunting.

Magritte's first paintings, executed in a loose, impressionist manner, date from about 1915. The following year he enrolled as a student at the Académie des Beaux-Arts in Brussels. Disillusioned with the teaching there, his attendance over the next two years was sporadic. But he did make the acquaintance of Victor Servranckx (1897–1965), a fellow student whose interests and ideas were soon to exert a certain influence over the direction of his own art. While at the Academy, or shortly after leaving it, Magritte was shown by his friend the painter and poet Pierre Bourgeois a catalogue containing reproductions of Futurist painting and for the next year or two he remained committed in his own work to echoing, probably not very satisfactorily, this radically new pictorial expression of the modern world. Unfortunately, very few of these so-called 'futurist' paintings survive, though we know from Magritte that they harboured strong erotic overtones. He associated this eroticism, which was to remain a conspicuous feature in his art, with the little girl in the cemetery and his original discovery of painting as a boy; he also described how it prevented him 'from falling into a more traditional search for formal perfection'.

Several works belonging to the years 1920–4, however, are characterized by just such a search, and it must have looked for a brief moment as if Magritte would become an abstract artist. The paintings of this period suggest a number of different sources within the tradition of Cubism and its cognates: the Orphism of Delaunay, with its dynamic fragmentation of solid matter through light and vivid colour contrasts; the more perfunctory, figurative Cubism of Metzinger; and Léger's great paintings of nudes in interiors of 1920–21. Magritte's *Woman* of 1923 (Plate 1) implies that his strongest debt was probably to Metzinger. The subject's featureless face and long body, the single viewpoint and bright lighting, and the artist's half-hearted attempts to 'analyse' the figure's solidity and merge it with its environment indicate that Magritte was not looking at front-rank Cubists such as Picasso or Braque but at the distillation and popularization of their discoveries in the work of some of their followers. But whatever the prototype, Magritte brings to these early paintings a quality that is peculiarly his own. Nearly all depict female nudes, singly (Fig. 15) or in groups of three, as in many of Léger's figure compositions of this date, but there is an inescapable element of sensuality about them quite

unlike Léger's monumental tubular women: the graceful curves of thigh and arm, the naturalistic colours including flesh pink and off-white, the relaxed poses, and the highlighting of sexual details such as the pubic hair — sometimes composed into the shape of a flower and at other times blurred as if the paint has been sprayed on with an airbrush (a piece of equipment with which, as a commercial artist, Magritte would have been familiar).

Magritte's retrospective opinion of such paintings was somewhat harsh. He considered them 'very evocative images but abstract and inert, and interesting, in the final analysis, only to the intelligence of the eye' — a judgement which ignores their inherent sensuality. Nor is there much in these canvases resembling the intricate geometry and narrow chromatic range of analytical Cubism: where abstract passages occur, they perform a decorative rather than a structural function. Nevertheless, certain works of this period seem inspired by the kind of pictorial idealism that we find in Léger's paintings of the 1920s. With this in mind we can now assess the part played by Victor Servranckx in Magritte's artistic development.

Magritte met up again with Servranckx when he went to work for a year under his supervision as draughtsman in a wallpaper factory, following his marriage to the twenty-one-year-old Georgette Berger on 28 June 1922. Magritte had known Georgette at Charleroi in his youth and had come across her again by chance in the spring of 1920, while out walking one day in the Botanical Gardens in Brussels. Before marrying, Magritte was obliged to perform his military service, which he did during the year 1921 and the first half of 1922 in an infantry regiment stationed first near Leopoldsburg and then at Antwerp. One of his companions was Pierre Bourgeois, brother of the architect Victor Bourgeois. Well before his conversion to Surrealism, Magritte was enjoying the company of avant-garde artists and writers in Brussels, where his pictures were occasionally exhibited and where he now settled with Georgette. But painting did not provide enough for the needs of the young couple, and Magritte was forced to seek employment.

Servranckx, with whom he now found himself, was an abstract artist whose ideas coincided with those being voiced at the time by the magazine *L'Esprit Nouveau,* organ of the formalist movement known as Purism, which had been launched in Paris after the

1914–18 War by the intellectual Amédée Ozenfant (1886–1966) and the architect Le Corbusier (1887–1967). Purism was essentially a reaction against the psychological upheaval of the War and against the iconoclastic side of Futurism, the nihilism of Dada and the idiosyncrasies which, it was felt, had been allowed to penetrate the Cubist revolution; it represented instead a 'return to order', to classical values of objectivity and harmony, combined with a twentieth-century belief in collectivism and anonymity. The Purists attempted to come to terms with modern industrial life in a positive, as opposed to a romantic or negative, fashion, and they held up the machine and the utilitarian objects which it manufactured as examples of the new beauty. Le Corbusier's ideal was *l'objet type* — the standardized, mass-produced object such as the bottle, carafe, bowl or glass which we use every day (Fig. 4). Purism gave birth to an art, and more especially an architecture, of pure abstract shapes and mechanical precision.

Servranckx was certainly enthusiastic about such a programme; his own 'machine paintings' were much admired by the Purists. In collaboration with Magritte he now wrote an essay called 'Pure Art: in defence of the aesthetic', and there is in existence at least one picture by Magritte (of 1922) that points to his influence. In it a figure, abstracted but still readable as a stylishly dressed lady, is seen riding a horse watched by two more figures against a background architecture of geometrical or mechanical shapes, including some of those discs resembling traffic signs that recur in Servranckx's paintings of this period. The surfaces of the painting are smoothly finished in reds, greens and browns, giving an almost slick appearance, a quality not always absent from Servranckx's work. With Magritte, however, this smooth finish was to be turned to advantage in the Surrealist paintings where it helps to throw into even sharper relief the unsettling nature of the image.

Of all the painters associated with Purism, it was Léger who contributed most to the movement's success. In his paintings of the 1920s, objects play an increasingly significant role; by 1927 such things as shells, leaves and keys have become enlarged and isolated, and seem to float in space before an abstract background. Léger's singling out of the object for special notice may be compared with a painting by Magritte of 1928, which has the revealing title of *Familiar Objects* (Plate 15). Here the head and upper torso of a man are seen from four different angles, one

Fig. 4
Still from the film 'Ballet Mécanique' by Fernand
Léger and Dudley Murphey
1924. LONDON, NATIONAL FILM ARCHIVE

of which is repeated. In front of the eyes of each figure, in one case masking them completely, float banal objects: a sponge, a jug, a shell, a ribbon tied in a bow, and a lemon. But it is not only the objects that claim our attention: the figures are painted exactly as if they were objects too, sharing the same drab clothes, sober hairstyles and expressionless, impenetrable faces. This tendency to present man as a kind of *homme type*, standardized and anonymous-looking, is noticeable in several other works by Magritte. In *The Threatened Assassin* (Plate 8), for instance, three identical heads like a row of balusters peer in at the macabre scene from outside the window, while the two bowler-hatted 'detectives' waiting to trap the sex-murderer are in every respect twins, except that one brandishes a club shaped like a human limb and the other holds ready a net. (The figures outside looking in and the bowler-hatted men may both derive from two paintings by Max Ernst which were illustrated at the time in the periodical *La Révolution Surréaliste*.) The expression on their faces is equally

11

USURPATION
LE FOLKLORE

Être paresseux, vide d'idées, avoir l'esprit comme un bric-à-brac, être le nombre, la foule, le *bourgeois*-roi d'aujourd'hui, et *spolier* bien rondement, sans précautions ni formules oratoires,

Fig. 5
Page from 'L'Art Decoratif d'Aujourd'hui' by
Le Corbusier
PARIS, 1925. PRIVATE COLLECTION

passive and vacant. People in Magritte's paintings frequently stare like this in a distracted way, as if in a trance; others keep their eyes closed, as if asleep or dead.

The elevation of the manufactured object reaches a climax in Magritte's *The Betrayal of Images* of 1929 (Plate 30), which consists of a realistically painted briar pipe with the words *Ceci n'est pas une pipe* written underneath. Magritte's preoccupation with the division between image and language will be discussed later; here we need only recall that Le Corbusier illustrated just such a pipe (Fig. 5) on the final page of his book *Towards an Architecture*, first published in Paris in 1923 and a cardinal document of Purism. The twisted columns that separate the narrative in Uccello's *The Profanation of the Host* (Fig. 6) have recently been proposed as a source for Magritte's frequent use of the baluster motif in his paintings. The Surrealists greatly admired Uccello (articles on his work were published in *La Révolution Surréaliste* and *Minotaure*) and there is little doubt that Magritte looked at the Old Masters: with their symmetry, frontality and pronounced perspective, his compositions often remind us of Quattrocento painting. But a more likely source within the context that we have been examining is Léger's painting *The Baluster* (Fig. 7), which hung in Le Corbusier's *Pavillon de l'Esprit Nouveau* at the 1925 Paris Exhibition.

Fig. 6
UCCELLO
Panel from 'The Profanation of the Host'
1465-8. URBINO, GALLERIA NAZIONALE DELLE MARCHE

Fig. 7
FERNAND LÉGER
The Baluster
OIL ON CANVAS, 130 × 97 CM. 1925. NEW YORK, THE MUSEUM OF
MODERN ART

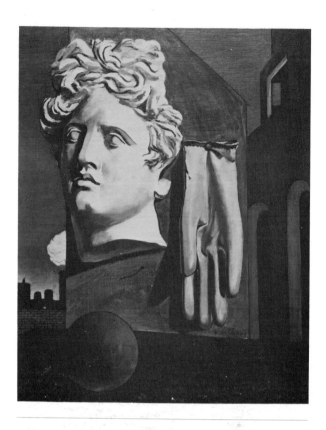

If this account of Magritte's early development seems to have placed too much emphasis on his Purist connections, it is precisely because Purism and Surrealism were such radically opposed philosophies: the one rationalist and anti-individualist, the other romantic, with a taste for the eccentric and one-off. When Magritte became a Surrealist, his interest in the formal properties of ordinary objects was modified, as we shall see, by a new Nietzschean sense of their metaphysical reality beyond appearance, which he inherited from de Chirico. However, the objects in his paintings bear no resemblance to the bizarre *objets trouvés* which other Surrealists were so fond of collecting.

After remaining for about a year in the wallpaper factory, Magritte left in 1923 to become a freelance poster and publicity designer. This activity con-tinued until 1926 when he signed a contract with the Galerie Le Centaure in Brussels, which enabled him to devote himself full-time to painting. There followed three years of intense artistic production in Paris, stimulated by contacts with the French Surrealists, but on his return to Brussels in the summer of 1930 Magritte was once again obliged to take up commercial work. His contract with Le Centaure had ended at the end of the previous year; shortly afterwards the gallery itself folded, with Mesens shrewdly, or bravely, buying up some two hundred of Magritte's canvases. Magritte's output of paintings declined considerably over the next six years as he channelled most of his energies into advertising. During this period he set up an agency called Studio Dongo with his brother Paul. It was not until 1937, with the increasing interest shown in his art by collectors like Claude Spaak and the Englishman Edward James, that his financial situation improved sufficiently for him to return to painting more or less full-time. Before assessing the effect which his various jobs in the commercial field had upon his art, we should first mention his discovery of the paintings of de Chirico, an experience that came as a revelation, turning him into a Surrealist almost overnight.

Probably during the year 1925, Magritte was shown by his friend the poet Marcel Lecomte some reproductions of de Chirico's work. He was particularly moved by *The Song of Love* (1913; Fig. 8), in which an antique mask, a surgeon's red rubber glove and a green ball are juxtaposed in a severe Italian townscape of sharp perspectives and long afternoon shadows; in the background a train passes by behind a brick wall. The three displaced objects, entirely out of scale with their surroundings, assume a kind of monstrous prominence and life of their own. De Chirico was steeped in the writings of Nietzsche and Schopenhauer who, he believed, 'were the first to teach the deep significance of the senselessness of life, and to show how this senselessness could be transformed into art'. The hallucinatory intensity with which de Chirico focuses upon unrelated, commonplace objects, coupled with his use of emotive perspective and more than one viewpoint, suggests an undermining of reality, which in the twenties was to prove irresistible to the Surrealist cult of alienation.

Several of de Chirico's 'magic objects' find their way into Magritte's own paintings: the plaster hand (Plate 4); the ball (Plate 5); the dismembered limb (Plates 4 and 8); the antique marble head (Plate 41);

14

and the train (Plate 40). In *The Difficult Crossing* (Plate 4), Magritte's use of the baluster, which here possesses an eye, is similar to de Chirico's use of the manikin figure in his paintings after 1914, where it replaces the statue as a mute human presence. The human-manikin analogy is central to Dada and Surrealist art, and Magritte plays on the disturbing implications of this animate-inanimate inversion in a number of important works. In *Midnight Marriage* (Plate 10), a painting related to de Chirico's *The Two Sisters* (1915), the back view of a decapitated male head is juxtaposed with the hollowed-out face of a bewigged dressmaker's dummy. Magritte employs various dramatic methods for obscuring a person's face, including back views (Plates 6 and 38), wrapping the head in material (Plates 19 and 23), and concealing or replacing the head by an object (Plates 6, 7 and 15). There exists also a series of pictures in

Fig. 9
The Lost Jockey

OIL ON CANVAS, 64.5 × 74.5 CM. 1926. PARIS, GALERIE DANIEL MALENGUE

which a statue is shown in the process of metamorphosis into a female nude, or vice versa — it is deliberately not clear which. In the appropriately titled *Black Magic* (Plate 32), of which there are several versions, some kind of extraordinary transformation seems to be taking place before our eyes. Such works look forward to the paintings of petrified humans and objects executed in the early 1950s, of which *The Song of the Violet* (Plate 45) is one of the most memorable; or to the burlesques on Manet's *The Balcony* and David's *Madame Récamier* painted at about the same time, where the figures are replaced by wooden coffins.

Certain of Magritte's early Surrealist paintings (1926–7) are especially reminiscent of de Chirico in their general atmosphere. The crowded compositions and enclosed spaces, the recurrence of frames, windows, mirrors and 'pictures within pictures', the cold lighting and the occasional exaggerated perspective all help to recreate the enigmatic stage-set effect of de Chirico's Metaphysical interiors. But above all it is the pointlessness and absurdity of de Chirico's images that Magritte takes over and refines. *The Secret Player* (Plate 9), a large, impressive work painted in pallid colours which add to its unreal quality, is clearly intended to be read as dream imagery, in which the conventional elements of narrative, space and time, are surrendered to a series of dissociated events and impressions. To answer the question 'What does it mean?', we can only turn to other pictures by Magritte containing similar iconographic puzzles. The terrapin-like creature floating above the heads of the baseball players features in another work of this period, *The Robe of Adventure* (1926), a painting whose genesis was probably the suicide of Magritte's mother, and it foreshadows the sinister flying objects which we encounter in *The Black Flag* (Plate 39). The avenue of balusters sprouting blossom is a direct question from *The Lost Jockey* (1926; Fig. 9), considered by Magritte to be his first successful Surrealist painting. The somnambulistic figure in the cupboard, masked and tightly corseted, is half nurse, half sex-object; no rational explanation of her presence seems possible, except that a strain of Sadeian sexual perversion or violence can be detected in several other paintings by Magritte (Plates 6, 8, 12, 21 and 35, and *Philosophy in the Boudoir*, 1947). Finally, the curtain drawn back to expose and frame the scene is a common theatrical device in works of this period.

There is an understandable temptation to interpret Magritte's early Surrealist pictures as a psychoanalyst would his patient's dreams — as voyages into the unconscious. Their titles — *The Magician's Accomplices*, *The Secret Player*, *Midnight Marriage* — hint at the enactment of shadowy private rites. In *The Reckless Sleeper* (Plate 11), the content of the sleeper's mysterious dream is represented almost ideographically by a few selected objects embedded in a molten substance. Dream motifs common to all of us are occasionally expressed in later paintings. The infantile sensation of growing infinitely large, for example, familiar to Alice in Wonderland and here transferred to an apple, is brilliantly evoked in *The Listening Room* (Plate 47). But on the whole Magritte's paintings after 1927 are less dreamlike, less complex in mood and organization, relying instead on the immediate impact of visual conceit or paradox — a strange meeting, an 'impossible' combination of objects, an even stranger metamorphosis. Many of them are analytical pictures, quasi-philosophical speculations into the nature and behaviour of things, or into the relationship between objects, the way we represent them, and the names we assign to them. Phenomena that we know to be reversals of natural law — a sky made of solid blue cubes, a wall of white clouds, an uninflammable object on fire, trees turned on their heads — seem feasible simply because Magritte has visualized them. With him, anything is possible: he acts like a conjuror, a magician, and it is no coincidence that he chose to portray himself thus, in *The Sorcerer* (Plate 44). In well-known works like *The Betrayal of Images* (Plate 30) and *The Human Condition* (Plate 33) he joins in the time-honoured debate about illusion and reality and asks fundamental questions about painting itself.

For this new kind of pictorial statement, both Magritte's experience of making collages and his activity as a commercial artist, soon to be resumed, proved to be of crucial importance. Max Ernst's collages of the 1920s, which were among the first manifestations of visual Surrealism and which, especially *La Femme 100 Têtes* (1929; Fig. 10) were full of erotic and sado-masochistic imagery, gave Magritte the idea that painting too could be pieced together from disparate elements. Ernst's imagery, procured from traditional sources such as old engravings and illustrations to magazines, was synthesized in such a way as to provoke disruptions in narrative and scale, as

Fig. 10
MAX ERNST
Collage in 'La Femme 100 Têtes'
PARIS, 1929

well as curious changes in texture. Magritte quickly realized that this technique was ideal for the forcing together of separate realities, and although he made few collages himself, it has often been remarked how the principle of collage underlies all his painted work. His pictures are full of images of torn and splintered shapes: fragments of wooden floorboard and marble fireplace (Plate 7), a broken wall (Plate 10), a cut-out face (Plate 14), a pierced door (Plate 31). In *Titanic Days* (Plate 21), a picture that describes a sexual assault on a woman, the figure of the male attacker is contained within the outline of his struggling victim, as if superimposed; in other words, form and content are interdependent and express the same violent physical union. This process of grafting or transplanting reaches an extreme in *The Rape* (Plate 35). Although both paintings are explicitly sexual in character, they are a far cry from the hot-blooded eroticism of, say, Picasso: the lighting remains harsh, the viewpoint cruelly frontal.

Whereas Max Ernst and the Cubists before him had incorporated in their canvases actual reminders of the physical world in the form of scraps of newsprint, pieces of wallpaper and so on, Magritte chose instead to render such things in paint with the precision and clarity of a *trompe-l'oeil*. There are numerous instances in his paintings where the surface texture of a particular material is simulated: wood, marble, granite, brick and stucco are the most common. Here again there is an affinity with Ernst, whose *frottages* are based on rubbings of similar textures. Like Ernst, Magritte appears to have undergone some kind of revelational experience while gazing, hypnotized, at the door-mouldings in a Brussels café in 1925.

As a wallpaper designer, Magritte would have been well versed in the techniques of illusionist painting. Most people are familiar with that species of wallpaper which comes in a variety of 'natural' finishes such as marble or wooden panelling, and there are plenty of occasions when Magritte reminds the viewer of this taste for *trompe-l'oeil* decoration, almost as if prompting him to ask 'Is it real or fake?'

Fig. 11
Man with a Newspaper
OIL ON CANVAS, 115.5 × 81 CM. 1928. LONDON, TATE GALLERY

— a question that has little meaning within the context of painting. *Ceci n'est pas une pipe*: it is the image of a pipe that we see, not the thing itself. Magritte plays games of this kind in several important pictures. *On the Threshold of Liberty* (Plate 25), for example, shows a room 'papered' with images that we have met before in his work: jingle bells, fire, paper latticework, the façade of a house, trees, clouds, some grainy wooden planks, and the trunk of a nude woman. A note of menace is struck by the unexplained presence of a cannon aimed directly at the woman's body, which suggests perhaps that the confines of this mad cell will burst in an explosion of sexual violence. The 'picture within a picture' theme is common to several works of the late twenties; in *The Empty Mask* (Plate 27), written words instead of painted images stand in for the objects themselves. A painting related both iconographically and in its expectant atmosphere to *On the Threshold of Liberty* is *A Courtesan's Palace* (Plate 24); here the ubiquity of wood-grain adds to the intensely claustrophobic nature of the space. This feeling of enclosure is transmitted even when Magritte opens up his interiors to the sky outside, as in *Personal Values* (Plate 46), a later work that relies on simple reversals of scale for its disconcerting effect. By far the most striking use of simulated natural finish occurs in *Discovery* (Plate 18), where we see a woman's body undergoing one of those dramatic transmutations that are a speciality of Magritte. Metamorphic imagery causes much of the shock that we experience when looking at Surrealist art, nowhere more so than when a change of material and texture, such as from flesh to wood, soft to hard, is involved. Meret Oppenheim's faintly repellent, slightly erotic *Object (fur breakfast)* (1936), which consists of an ordinary cup, saucer and spoon, covered with animal fur, represents the ultimate in this genre of transmogrified things or beings.

Magritte's preference for isolating his imagery in separate boxes or compartments, and at times duplicating it, may also have had its roots in his commercial work. In *On the Threshold of Liberty* and similar paintings there is no serial or causal connection between the panels so that it is impossible to read the images as one would those of a strip cartoon, for instance. Duplicated images such as are found in *The End of Contemplation* (1927) and in the Tate Gallery's *Man with a Newspaper* (1928; Fig. 11) may remind us of advertising techniques or the pattern repeats on wallpaper or fabric, both of which Magritte designed,

although the latter painting was in fact based on an engraving from a popular guidebook to natural health, which Magritte owned and used on at least one other occasion; it may also have connections with such diverse sources as stereoscopy and shop-window display, as has recently been suggested. *The Double Secret* (Plate 14) and *Not to be Reproduced* (Plate 38) represent simple variations on the same theme; in the latter work the effect is one of visual double-take. The parcelling up of the image assumes concrete form in *The Eternal Evidence* (Plate 29), which consists of five framed canvases, each like a small, self-contained icon and each showing part of a woman's body. Fitted together the parts do not add up to the whole — arms and shoulders, for example, are missing — so that the work resembles a weird party game or puzzle. Magritte's women (usually portraits of his wife Georgette) often have something of the mysterious and unattainable about them.

By dividing his pictures into sections, Magritte was able to schematize the Surrealist habit of conflating events or situations normally considered irreconcilable in the non-temporal art of painting: what is perceived, and what is remembered, imagined or dreamt. Instead of the Cubist-inspired shifts in focus and perspective of a de Chirico, something even more uncompromising happens: a break with the traditional notion of composition as a unifying aesthetic force. In *The Reckless Sleeper* (Plate 11) the entombed figure (the material world) and his dream (the mental world) claim equal attention as the picture's subject.

Between 1924 and 1927 Magritte did publicity work for the celebrated Brussels *couture* house Norine, founded by Norine and Paul-Gustave Van Hecke. In the thirties, Norine incorporated motifs from Surrealist paintings in some of their dress designs. Van Hecke was responsible in 1926 for bringing Magritte's painting to the notice of the Galerie Le Centaure, which gave him his first one-man exhibition in the spring of the following year; among the sixty or so works on show were *The Signs of Evening* (Plate 5), *The Difficult Crossing* (Plate 4) and *The Threatened Assassin* (Plate 8). From 1928 to 1930 Van Hecke edited a review called *Variétés*, to which Magritte contributed drawings, including a cover illustration (Fig. 23) based on his painting *The Lovers* (Plate 23). *Variétés*, for which Magritte also did publicity work, was more in tune with the modern world of fashion, advertising, photography and the cinema than were the Parisian Surrealist periodicals of the

twenties and early thirties. Its standard of reproduction was particularly good, with E.L.T. Mesens as picture editor responsible for some intriguing juxtapositions and unusual subjects, which may well have influenced Magritte's painting.

Magritte also illustrated a catalogue for a Brussels furrier, Maison Samuel (Fig. 12), which had mildly suggestive captions written in a form of a parody by his friend Paul Nougé who became the main spokesman for Surrealism in Belgium. It would not be too fanciful to regard *The Rape* (Plate 35) as one of Magritte's fur illustrations given a nasty, ironic twist. The erotic ingredient in his early Cubist canvases is even more pronounced in the fashion-plates which he did for Samuel; in those that show mink coats draped provocatively round female models or manikins there is a noticeable tendency to throw into relief the soft texture of the fur. If in *The Rape* Magritte is suggesting an analogy between animal and human hair, he also brings to the surface a complex phobia — the same aversion to fur and feathers that Ernst plays on in many of his paintings. Magritte occasionally paints birds, both alive and dead, as in *Young Girl Eating a Bird* (Plate 12), a macabre work that is almost certainly symbolic of loss of sexual innocence.

To demonstrate how closely Magritte's painting and graphic design activities were interrelated during the early and middle years of the twenties one has only to look at a picture like the 1925 *Bather* (Plate 2). In many ways it is a transitional work. The colours are still the flat pastels favoured by the Purists, the 'architecture' is reduced to basic geometric forms, and yet an incipient Surrealism can be detected in certain details — the large ball in the background, the window revealing an expanse of sea, and the drapery at either side. It is instructive to compare this painting with a later work, *The Bather between Light and Darkness* (Plate 3), in which the same ideas are more successfully developed; here the ball has moved into the foreground, posing a real threat, the window looks more like a picture, and the reclining figure is naked, her eyes closed. But what concerns us about the earlier *Bather* is her stylish, Modiglianiesque pose, her Art Deco appearance, which scarcely distinguishes the picture from an advertisement for a woman's bathing costume and cap.

If Magritte's work in the commercial sphere provided him with a number of techniques and motifs that he found useful to his art, its most important legacy was perhaps a more fundamental belief in the

20

Fig. 12
Illustrations for La Maison
Samuel Fur Catalogue

functional character of painting — that painting is essentially a vehicle for an idea, not to be exploited for showing off sensuous colours or feats of technical virtuosity. Magritte deliberately affected a smooth, poster-like style, which is not to say that he was an inferior painter: anyone looking at the plates in this book will appreciate that he is in the presence of one who handles light and colour with rare skill. But on the whole the artist in Magritte's pre-war work is reduced to a neutral, recording role. This is fully consistent with one of the chief aims of Surrealism, which was to disrupt the senses by inverting traditional modes of communication, whether written, spoken or visual: the more conventional the language, the greater the derangement. The photographs that Magritte took from 1928 onwards as 'notes' towards some of his paintings, for which his wife and friends would pose, disclose even more clearly his indifference to the medium: the thought was what counted. These snapshots, some of which recall the kind of trick or joke photograph illustrated in *Variétés*, also show how childish at times Magritte's sense of humour could be, but how often this childishness concealed both a blackness and a sharp cutting edge.

Magritte claimed, somewhat over-ingenuously, that he had no tastes in art, his admiration being reserved, rather like Léger's was, for the largely unsigned products of popular culture: postcards, shop signs, gangster and suspense films, illustrations to thriller magazines. It has often been pointed out how this liking for ephemera is mirrored in his paintings, and David Sylvester has recently discovered a source in erotic postcards for a handful of works. (Erotic or pornographic postcards were collected by other Surrealists, notably Dalí and the poet Paul Eluard.) There can be no question that a certain genre of French and German picture postcards of the 1900–1920 period greatly appealed to Magritte's Surrealist eye. There was, for example, a wealth of cards on the theme of travel in which, by a primitive photomontage technique, objects and animals were shown flying about the sky in defiance of gravity — cars, turtles, fish, and even a lion — as well as legitimate flying vehicles such as Zeppelins, airships, bi- and triplanes and balloons. The attraction for Magritte of this surprisingly rich vein of fantasy becomes perfectly clear if we consider *The Black Flag* (Plate 39), *The Age of Enlightenment* (Plate 48) or a number of similar paintings. But it should not be forgotten that

some of the more grotesque allegorical paintings of the Flemish Old Masters contain bizarre flying creatures. Bosch and Bruegel (Fig. 13), both greatly admired by the Surrealists, are obvious examples, but the works of Huys and Lucas van Leyden also boast monstrous inventions such as reappear in Magritte: severed limbs treated as independent beings (*Intermission*, Plate 16), deformed or elongated noses (*The Philosopher's Lamp*, 1936), and various kinds of hybrid. Magritte could have seen works by these artists in the museum in Brussels. He might also have found in early Flemish religious painting a precedent both for his suspension in space of dislocated parts of the face and body, as in *The Age of Enlightenment*, and for the incorporation of written words in the composition.

During the three years that he spent in Paris (1927–30), Magritte produced a number of works which were probably influenced by his proximity to certain of the Paris-based Surrealists. He had already been impressed by Max Ernst's basically figurative paintings of the early twenties, some of which were illustrated in the magazine *La Révolution Surréaliste*, but he was now drawn to the more informal, abstract configurations in the work of artists like Arp, Tanguy, Miró and, to a lesser extent, Ernst too. These paintings of Magritte's are characterized by the emergence of biomorphic or organic shapes, as in *Intermission* (Plate 16) and *The Celestial Muscles* (Plate 17) — the latter bears a slight formal resemblance to Ernst's forest paintings — and by a curious device of setting images in a substance which is sometimes soft and malleable and which at other times looks like one of Arp's painted wooden reliefs (Plates 11 and 28). The pages of *La Révolution Surréaliste* and *Variétés* were sprinkled with articles and photographs exploring such typically Surrealist interests as hypnosis, madness and hysteria, and there are a handful of paintings by Magritte which reflect these tastes (Plates 13 and 20). On the whole Magritte was much less enthusiastic than his Parisian friends were about such subjects, though he did contribute a drawing to the book which the Surrealists produced in 1933 as a homage to Violette Nozières, who had murdered her incestuous father (Fig. 14).

The Paris period is important primarily for Magritte's introduction of words into his pictures. The relationship between an object, its name and its representation was discussed by Magritte at the time in an illustrated text which he published in *La*

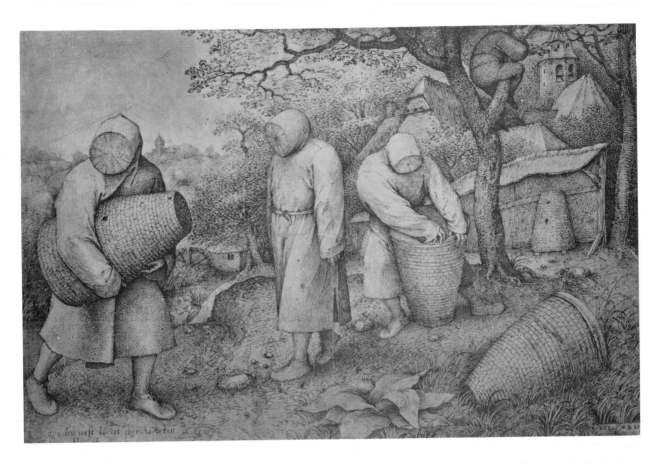

Fig. 13
PIETER BRUEGEL THE ELDER
The Bee-Keepers

PEN AND INK, 20.3 × 30.8 CM. C.1568. BERLIN,
KUPFERSTICHKABINETT

Révolution Surréaliste. This relationship is examined in a series of paintings in which words start by designating images of the material world, proceed to challenge them, and end up by replacing them altogether, so that the effect is not unlike that of a work of conceptual art (*The Empty Mask*, Plate 27). In his text 'Words and Images', Magritte wrote that 'a nondescript form can replace the image of an object', an idea that lies behind *The Use of Speech* (Plate 26). In shape and colour the nondescript forms in this painting, marked 'mirror' and 'woman's body', strongly

resemble excrement, but in another work, *The Magic Mirror* (Plate 28), there is a closer affinity between the partly flesh-pink biomorph and its written designation, 'human body'. The notion of painting as a sign language was dear to the Surrealists, but Magritte's use of words is quite different from, say, the visual shorthand practised by Miró, however much at times it seems to parody it. Not without reason have his paintings been compared to the picture language of children's alphabet books.

In the 1930s Magritte's conception of his own painting changed. Instead of bringing about a collision between incompatible things, he saw it as posing and solving certain hypothetical questions: 'the problem of the door' (Plate 31), 'the problem of the window' (Plate 33), 'the problem of shoes' (Plate 36), and so on. We should think of these works as pictorial epigrams or arguments in which the various stages of the argument have become inextricably fused, according to a principle of affinity between objects which Magritte recognized. The version of *The Red Model*

23

illustrated here (Plate 36) was one of a handful of works painted specially for Edward James, an enthusiastic collector of Surrealist art who invited Magritte to stay with him in London early in 1937. This visit was engineered by Mesens who had been one of the organizers of the International Surrealist Exhibition in London the previous year and who later took over the running of the London Gallery, where Magritte was given a one-man show in 1938 (Fig. 39). *The Red Model* exists in at least three versions; the James variant, which is the last, is the largest and most elaborate (and, as such, possibly the least powerful in impact). Lying in the shingle beneath Magritte's extraordinary metamorphic creation (boot or foot? container or thing contained?), which here has none of the fetishistic overtones suggested by the woman's high-heeled shoes in the Sadeian *Philosophy in the Boudoir* (1947), one can make out some English coins, the stub of a cigarette, a match, and a crumpled fragment of newspaper — emblems of transience, perhaps, in a modern *Vanitas* still-life. On closer inspection the piece of newspaper is seen to contain a reference to Magritte's own work in the form of a reversed photograph of an earlier painting, *Titanic Days* (Plate 21), whose subject is a sexual attack on a woman. Another painting commissioned by James, *Not to be Reproduced* (Plate 38), which is an ironic portrait of the collector, can also be interpreted as a kind of oblique self-portrait. The clue here is the book on the mantelpiece, *The Adventures of Arthur Gordon Pym* by Edgar Allan Poe, which, unlike James, is faithfully reflected in the mirror. Poe was Magritte's favourite author; he borrowed several titles for his paintings from works by Poe, as well as from Baudelaire, Lewis Carroll, R.L. Stevenson and other nineteenth-century authors he admired. Magritte's titles, which were given after the picture was finished, sometimes by friends, are usually allusive or punning rather than descriptive; occasionally they deliberately contradict the image.

Given the worsening political situation in Europe during the thirties, it is not surprising that Magritte, like so many artists and writers of his generation, should have briefly belonged to the Communist Party. But politics had little effect on his painting. A possible exception is *The Black Flag* (Plate 39), which may refer to an event such as the bombing of Guernica during the Spanish Civil War, and whose title has a decidedly anarchist ring. What did affect Magritte, however, was the experience of living out the Second World War in occupied Belgium, which persuaded him to alter radically his attitude towards his own painting and towards Surrealism in general. In 1943 he began to paint in a bright, colourful style, which parodied the Impressionist paintings of Monet and Renoir. The problem of colour now replaced the earlier preoccupation with objects. This 'radiant period', as it was dubbed, lasted for about four years and co-existed with works executed in Magritte's more familiar style; it is characterized by paintings in which pleasurable or erotic sensations are substituted for the feelings of alienation and anxiety generated by the pre-war Surrealist works — sometimes irreverently so, as in *The Ocean* (Plate 42).

In 1946 Magritte broke with Breton over these 'impressionist' pictures. In a letter to Breton of 24 June of that year he renounced Surrealism in the following terms:

'This sense of chaos, of panic, which Surrealism hoped to foster so that everything might be called into question was achieved much more successfully by those idiots the Nazis, and then there was no getting away from it. I painted a picture, *The Black Flag*, which gave a foretaste of the terror which would come from air missiles, and I'm not proud of it . . . Against widespread pessimism, I now propose a search for joy and pleasure.'

This was followed a few months later by the publication of a manifesto, *Surrealism in Full Sunlight*, signed by Magritte and several Belgian Surrealists. Magritte also wrote in 1946 an enthusiastic introduction to an exhibition of Picabia, another artist who opposed Surrealism with 'superficial' pictures full of 'flashes of vivid light', which 'escape from fixed ideas', and 'inaugurate this reign of pleasure that ought to be brought within the limits of our lives'. But the public was not to be let off so lightly. The following year (1947) Magritte tried a little experiment. To counteract the complacency, the false sense of optimism, which he thought might have resulted from his impressionist works, he painted in a short

Fig. 14
Illustration to 'Violette Nozières'
(ENLARGED.) BRUSSELS, 1933

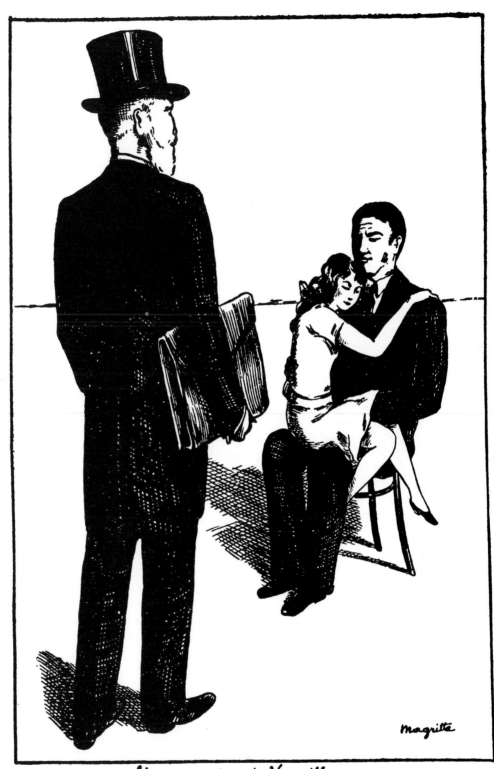

L'impromptu de Versailles

space of time a number of absurd or grotesque subjects in a savage, impetuous manner (Fig. 43). He called these paintings by a vulgar French word, *vache*. They were exhibited in the early summer of 1948 at the Galerie du Faubourg in Paris — Magritte's first one-man show in the French capital — accompanied by a text written in an equally crude, colloquial idiom by Louis Scutenaire. Magritte's provocative gesture was aimed at the hallowed tradition of *belle peinture*, and it is worth recalling that a return to primitive sources was characteristic of other artists active in Paris in the immediate post-war years. Dubuffet was busy forming his collection of *l'art brut*, by mental patients and social outcasts, while in 1948 the COBRA movement, whose members also sought inspiration in various extreme expressions of alternative culture, was founded in Paris. In *The Pebble* (Plate 43), however, Magritte shows how beautifully he could paint a shocking subject if he so wished.

The *vache* interlude was a brief and highly unpopular one, and a disillusioned Magritte soon retreated into his old style. Much of the sting, however, had gone out of his work: there is something a trifle flat (perhaps deliberately so) about the imagery of many of the paintings executed in the late 1950s and 1960s. This was the period when Magritte became absorbed in painting variations of his own previous work, and while it is true to say that he constantly guarded against the danger of mechanical repetition, the several versions that exist of a particular painting seldom add to what we know, although they do show us an artist thinking intently about the world and its mysteries in a detached, objective way. Painting,

Magritte felt, was not meant to expound ideas or express emotions, but should ask questions about the known visible world in the form of puzzles or conceits. 'The art of painting is an art of thinking,' he wrote in 1949, its aim being 'to perfect sight through a pure visual perception of the exterior world'. In 1953 he completed a large decorative scheme for the Casino at Knokke-le-Zoute, which, borrowing from Poe, he called *The Enchanted Domain*. This magnificent frieze, with its quotations from earlier paintings, can be taken as a compendium of his art, a final summing up of the thoughts that had engaged his mind for thirty years.

In the sixties, public interest in Magritte increased enormously, and there were two major retrospective exhibitions of his work before his death in the summer of 1967. This rediscovery of a by then almost neglected figure was largely due to the enthusiasm of certain inquisitive young artists who realized that Magritte had anticipated and attempted to come to grips with many of the issues that concerned them. His background in commercial art, his interest in mass culture and use of multiplied imagery, his belief that art is as much the product of mental activity as of instinct or emotion, his attempt to demystify the artist's status to that of an objective recorder of information, and, not least, his reliance on simple, 'logical' pictorial statements: all this profoundly influenced a generation of Pop, Minimal and Conceptual artists who are still with us today. More recently, Magritte's *vache* pictures have finally been recognized for the powerful, prophetic images they are, as an even younger generation of 'nasty', 'wild' or 'ugly' painters returns to figurative art with a vengeance.

Outline Biography

1898 Born 21 November at Lessines, in the province of Hainaut, Belgium, the eldest of three brothers.

1912 Suicide of Magritte's mother.

1915 Begins to paint, in an impressionist style.

1916–18 Studies intermittently at the Académie des Beaux-Arts in Brussels, where his family settles in 1918.

1919 Paintings influenced by Futurism.

1920 Meets E. L. T. Mesens.

1921–22 Military Service.

1922 Marries Georgette Berger. Works for a year in a wallpaper factory.

1923 Becomes poster and publicity designer. Paintings of this period owe much to Magritte's interest in Cubism and Purism.

1925 Collaborates with Mesens on Dada review *Œsophage*. Encounters work of de Chirico.

1926 Collaborates with Mesens on review *Marie*. Makes collages. First Surrealist paintings.

1927 First one-man exhibition at the Galerie Le Centaure, in Brussels. Moves to Le Perreux-sur-Marne, a Paris suburb.

1927–30 In close touch with Parisian Surrealists, with whom he exhibits. Maintains contact with Belgian Surrealists.

1928 Contributes drawings and texts to the Belgian surrealist review *Distances*, edited by Paul Nougé.

1928–30 Contributes drawings and does publicity work for *Variétés*, a magazine edited by Paul-Gustave Van Hecke.

1929 Spends the summer with Dalí in Spain. Magritte's text 'Words and Images' published in *La Révolution Surréaliste*, 15 December. Termination of contract with Brussels dealer.

1930 Returns to Brussels. Obliged to work again as a commercial artist. Sets up advertising agency with his brother Paul.

1936 First exhibition of Magritte in U.S.A. Takes part in the International Surrealist Exhibition in London.

1937 At the invitation of Edward James, spends several weeks in London.

1938 Takes part in the International Surrealist Exhibition, Paris. One-man exhibition in London. 20 November: delivers autobiographical lecture, 'Lifeline', at the Museum in Anvers (not published until 1946).

1940 Leaves Belgium before the German invasion and spends three months at Carcassonne in the south of France. Returns to Brussels.

1943–47 'Impressionist' period.

1947 Publication of first monograph on Magritte, by Louis Scutenaire.

1947–48 *Vache* period.

1953 Executes large decorative project, called *The Enchanted Domain*, for the Casino at Knokke-le-Zoute, Belgium.

1954 First retrospective exhibition, Brussels.

1965 Retrospective exhibition, New York.

1967 Retrospective exhibition, Rotterdam. Death of René Magritte in Brussels, 15 August.

Select Bibliography

Waldberg, Patrick, *René Magritte*. Brussels, 1965.

Soby, James Thrall, *René Magritte*. Museum of Modern Art, New York, 1965.

Gablik, Suzi, *Magritte*. London, 1970.

Passeron, René, *René Magritte*. Paris, 1970.

Scutenaire, Louis, *Avec Magritte*. Brussels, 1977.

Torczyner, Harry, *Magritte: Ideas and Images*. New York, 1977.

Mariën, Marcel, *L'Activité Surréaliste en Belgique*. Brussels, 1979.

Magritte, René, *Ecrits Complets*. Edited by André Blavier. Paris, 1979.

Schiebler, Ralf, *Die Kunsttheorie René Magrittes*. Munich, 1981.

Levy, Silvano, 'René Magritte and Window Display', *Artscribe*, No. 28, March 1981, pp. 24–8.

EXHIBITION CATALOGUES

René Magritte: le mystère de la réalité. Museum Boymans – van Beuningen, Rotterdam, 1967 (introduction by Jean Dypréau).

Sylvester, David, *Magritte*. Arts Council of Great Britain, Tate Gallery, London, 1969.

Ades, Dawn, and others, *Dada and Surrealism Reviewed*. Arts Council of Great Britain, Hayward Gallery, London, 1978 (especially sections 9, 13, 16 and 17).

Rétrospective Magritte. Palais des Beaux-Arts, Brussels, and Centre Georges Pompidou, Paris, 1978–9.

Glozer, Laszlo, and others, *Westkunst: Zeitgenössische Kunst seit 1939*. Cologne, summer 1981 (especially pp. 160–3 and 393–4).

René Magritte und der Surrealismus in Belgien. Kunstverein und Kunsthaus Hamburg, January–March 1982.

A full bibliography up to 1965, compiled by André Blavier, is provided at the back of Waldberg.

A *catalogue raisonné* of Magritte's work is being prepared by David Sylvester.

List of Illustrations

Colour Plates

Text Figures

Comparative Figures

30

Woman/Femme

OIL ON CANVAS, 100 × 70 CM. 1923. PRIVATE COLLECTION

Magritte's early pictures, before he discovered de Chirico and became a Surrealist, show the influence of Cubist and Purist techniques (Fig. 15). It is worth noting that the other great illusionist Surrealist, Salvador Dalí, went through a similar phase in the twenties of breaking up the figure or object into geometric segments and introducing ideal forms.

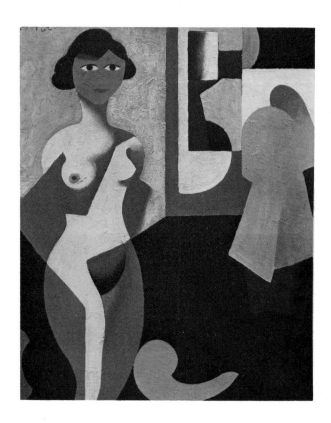

Fig. 15
The Model

OIL ON CANVAS, 65 × 54 CM. 1922. BRUSSELS, COLLECTION ISY BRACHOT

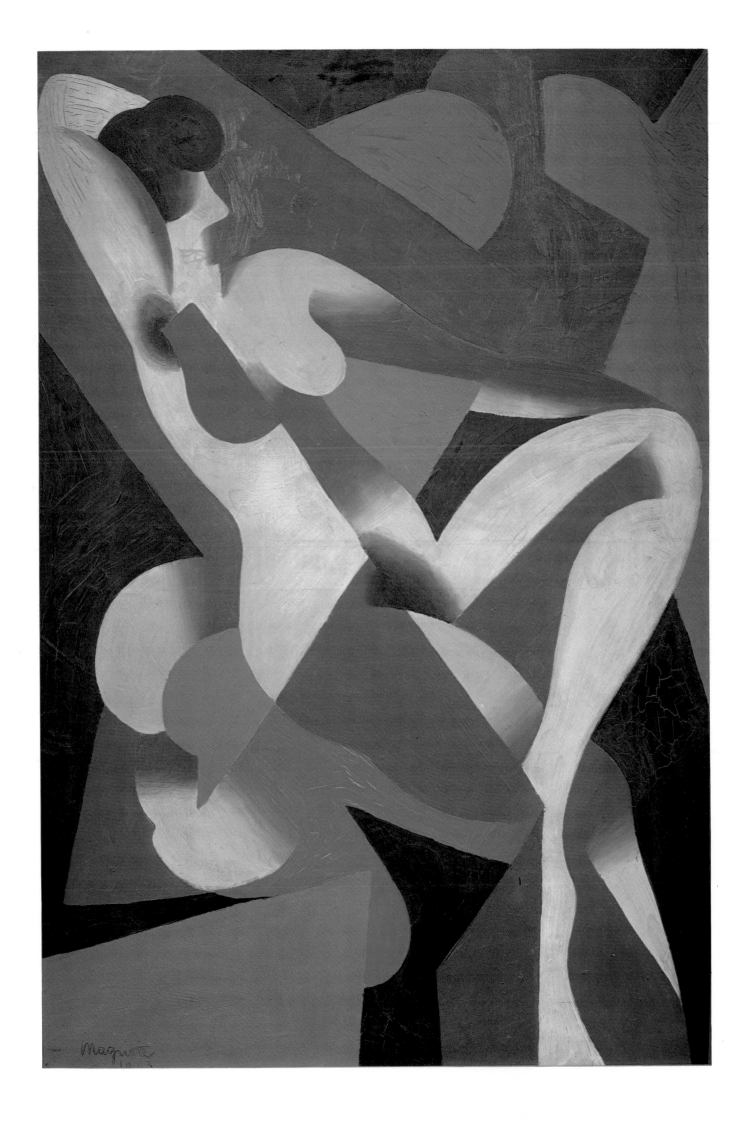

Bather/Baigneuse

OIL ON CANVAS, 50 × 100 CM. 1925. PRIVATE COLLECTION

In 1923 Magritte left his job as draughtsman in a wallpaper factory to become a commercial artist. For the next three years he designed posters and advertisements for a number of Brussels firms such as the famous *couture* house Norine, run by his friends Norine and Paul-Gustave Van Hecke. Van Hecke later founded and edited the magazine

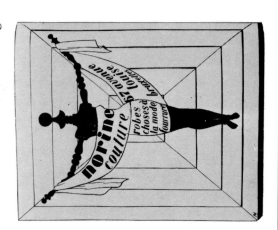

Fig. 16
Advertisement for Norine
ILLUSTRATED IN 'VARIÉTÉS', MAY 1929

Variétés for which Magritte did publicity work and to which he contributed the occasional drawing. Thanks to Van Hecke, who arranged for Magritte's first one-man exhibition at the Galerie Le Centaure in Brussels in April 1927, Magritte was able to concentrate more or less exclusively on his own art between 1927 and 1930. These were the years he spent in Paris, in close touch with the Parisian Surrealist group, although he retained contact with his friends in Belgium. On his return to Brussels in 1930 Magritte was once again forced to resume part-time commercial work.

Fashion and presentation techniques certainly had an impact on Magritte's painting, as can be seen in *The Bather*. In the advertisement for Norine (Fig. 16), the head and arms of the manikin have been transformed by Magritte into his favourite *bilboquet* or baluster. The photographs from *Variétés* were among several showing the recently opened gentleman's tailors, Knižé, on the Champs Elysées in Paris (Fig. 17). The Paris shop of this Viennese firm was designed in 1927 by Adolf Loos (1870–1933), whose architecture and writings were much admired by the Purists. (*Variétés* frequently illustrated photographs showing still-life arrangements of identical mass-produced objects of the kind favoured by the Purists,

and even published an article on the 'machine aesthetic'.) The shop's emblem, a lay figure dressed as a polo player astride an articulated wooden horse, bears a coincidental resemblance to the jockey who recurs in Magritte's painting from 1926 onwards.

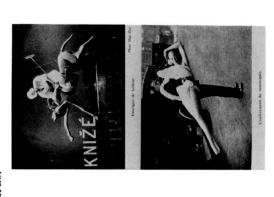

Fig. 17
Photographs in 'Variétés'
(top, by Man Ray)
DECEMBER 1928

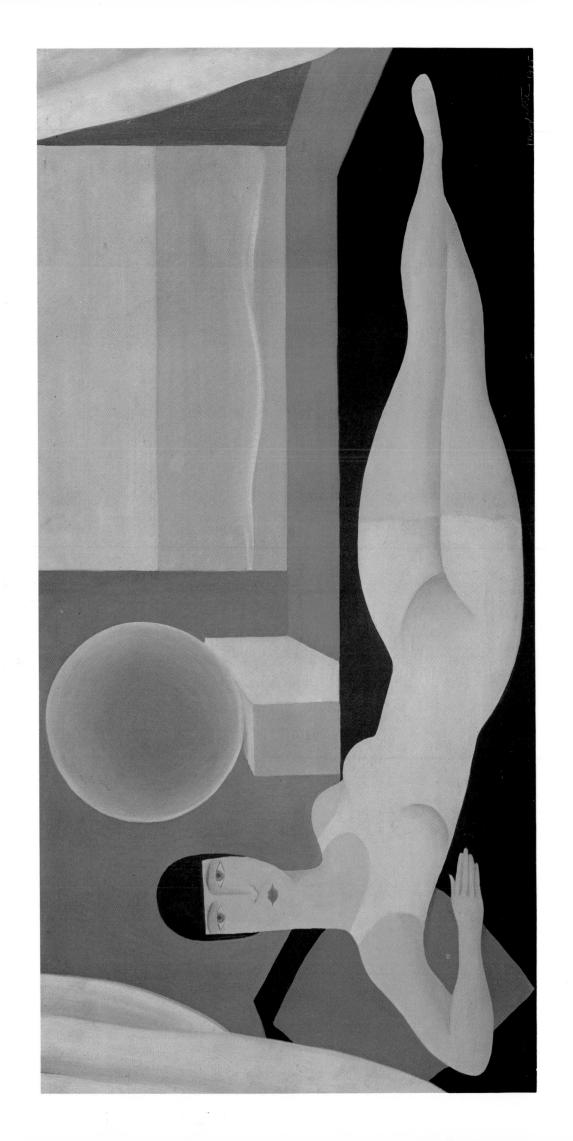

The Bather between Light and Darkness/La baigneuse du clair au sombre

OIL ON CANVAS. 89 × 115 CM. 1935 OR 1936. PRIVATE COLLECTION

Although there are obvious differences between this fully fledged Surrealist painting and the 1925 *Bather* (Plate 2), Magritte's technique remains fundamentally unchanged a decade later. Except for the 'impressionist' and *vache* phases of the 1940s, he never abandoned his dry, matter-of-fact style, which he probably inherited from his work in poster design.

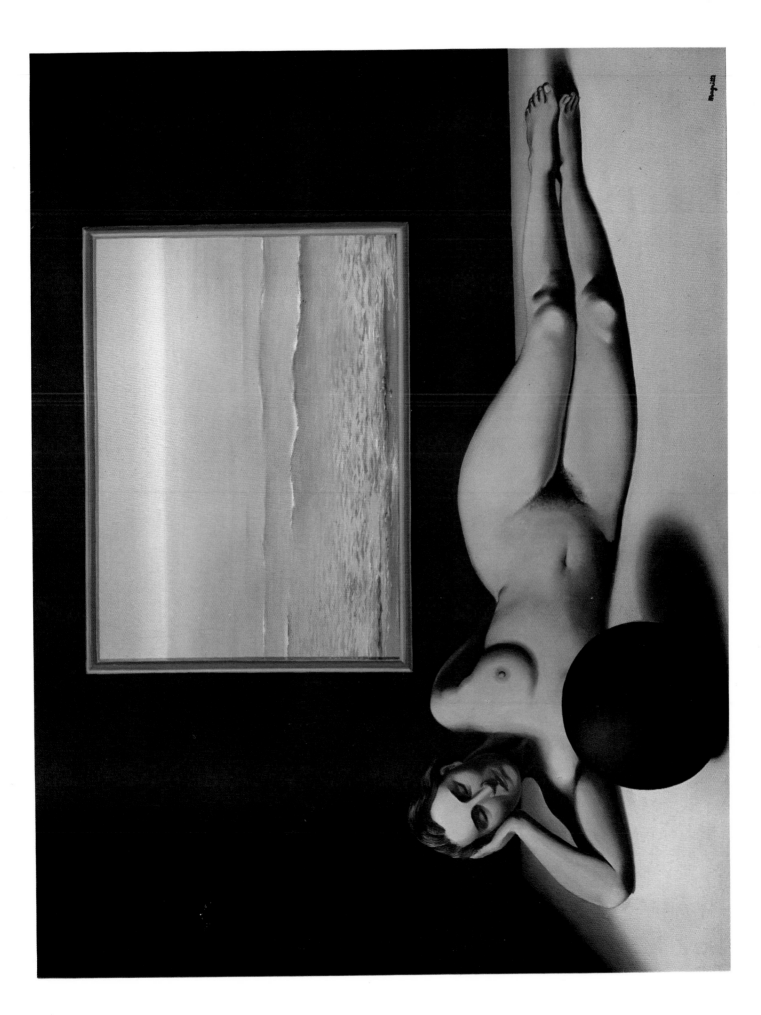

Magritte

The Difficult Crossing/La traversée difficile

OIL ON CANVAS, 80 × 65.3 CM. 1926. PRIVATE COLLECTION

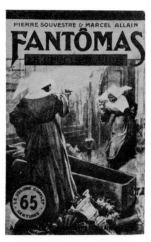
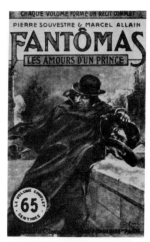

This is one of the first works to indicate that Magritte rapidly absorbed the strange, theatrical atmosphere of de Chirico's 'illogical' interiors. The plaster hand on the table may derive from a cover for one of the *Fantômas* books (Fig. 18; see also the note to Plate 8), and the dismembered limb acting as a table-leg is a device we shall meet again, in different guise, in *The Threatened Assassin* (Plate 8).

Fig. 18
Four Covers for 'Fantômas'
PAGE IN 'DOCUMENTS', NO. 1, 1930

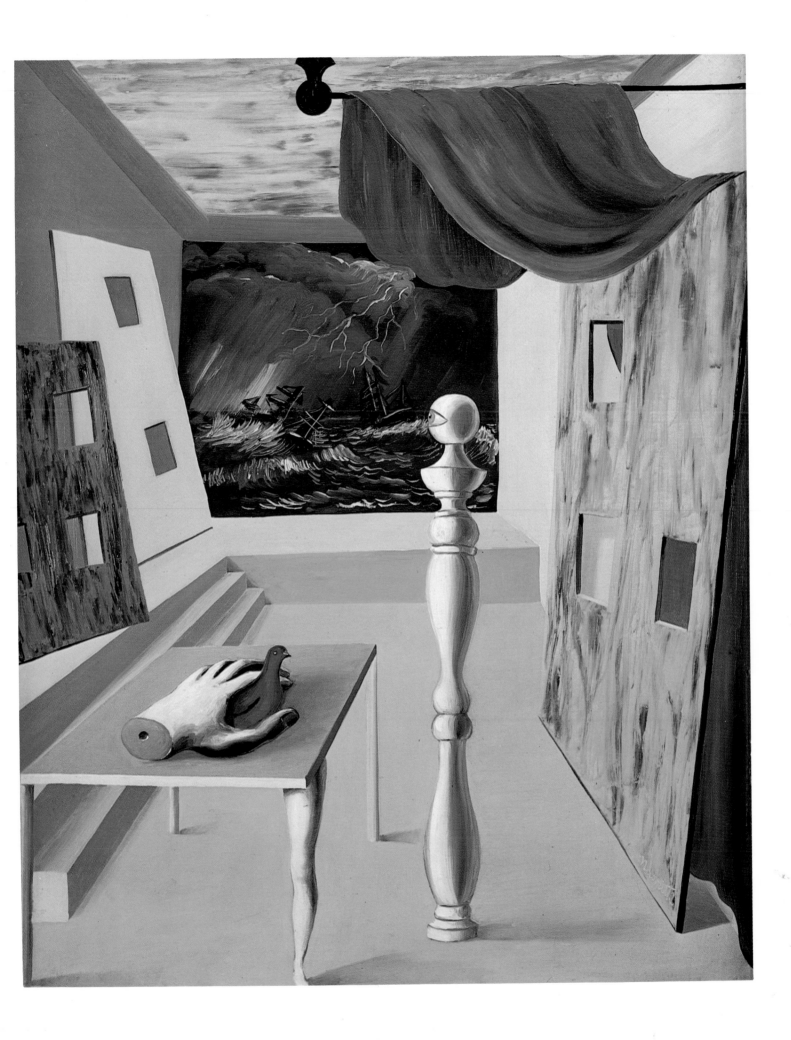

The Signs of Evening/Les signes du soir

OIL ON CANVAS, 75 × 65 CM. 1926. PRIVATE COLLECTION

The picture within a picture, which probably derives from the ambiguous, charged imagery of de Chirico's Metaphysical interiors, with their framed maps and diagrams, is one of Magritte's most frequent devices (see also Plates 2, 3, 4, 24, 25, and 33). The ball may also be a quotation from de Chirico, some of whose still-lifes contain geometrical solids. This painting was one of nearly fifty oils included in Magritte's first one-man exhibition at the Galerie Le Centaure, Brussels, in the spring of 1927. Also shown were Plates 4, 6, 7, 8 and 9.

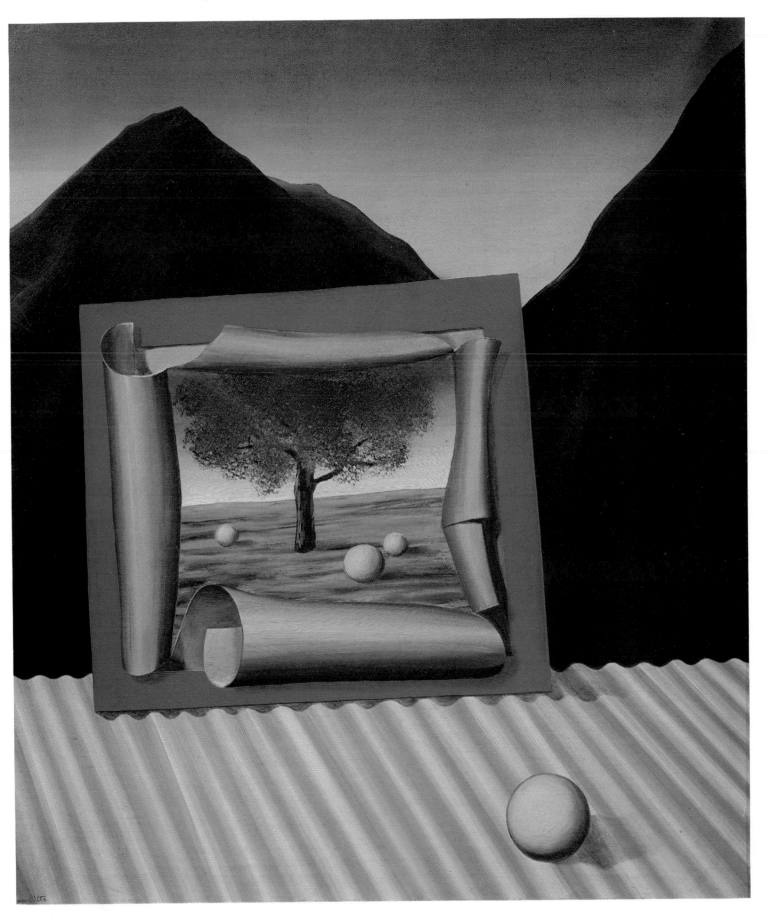

The Magician's Accomplices/Les complices du magicien

OIL ON CANVAS, 139.2 × 105.7 CM. 1926. PRIVATE COLLECTION

The faces of the figures in this painting are concealed, implying a loss of identity and contributing to the feeling of silence that pervades the scene. On a platform or stage a perverse ritual with distinctly sadistic overtones seems about to take place. As in other works, the figures are incomplete or shown cut off.

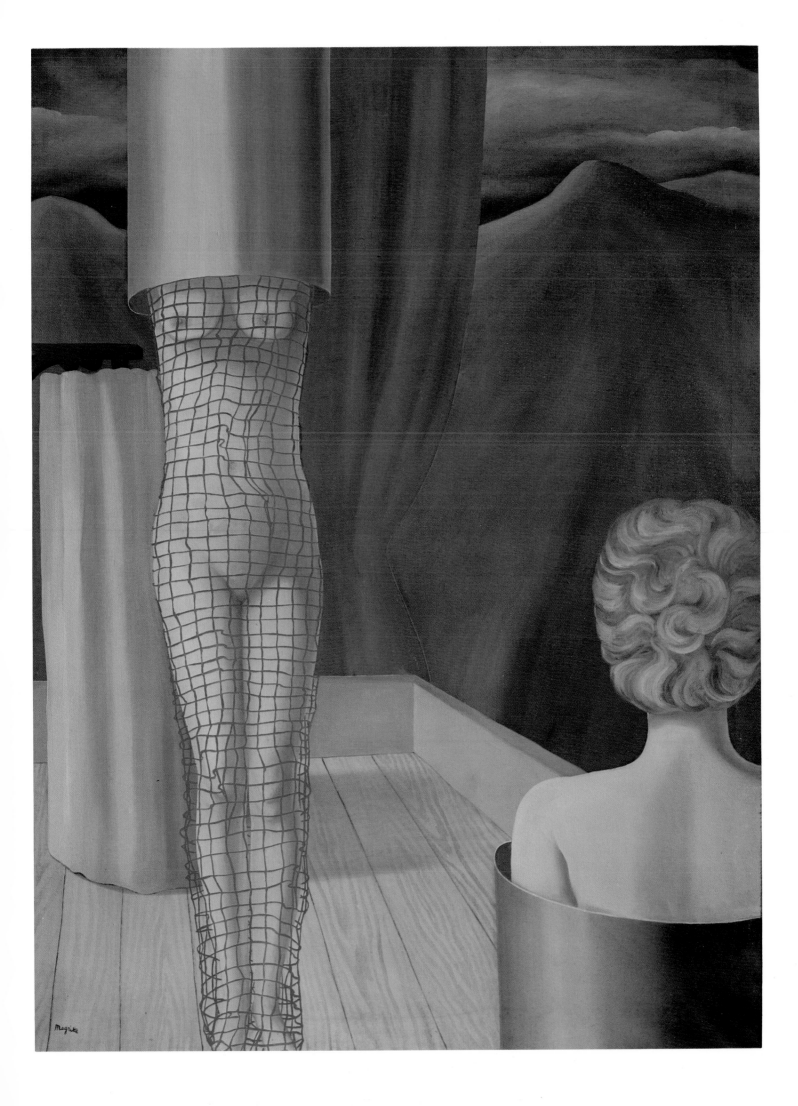

The Man of the Sea/L'homme du large

OIL ON CANVAS, 139 × 105 CM. 1926 OR 1927. BRUSSELS, MUSÉES ROYAUX DES BEAUX-ARTS DE BELGIQUE

Of all Magritte's early Surrealist paintings, *The Man of the Sea* exemplifies most clearly his debt to collage. The rubber-suited figure, as anonymous as one of de Chirico's manikins, holds a piece of broken glass door or window. Below him are fragments of marble chimney-piece, wooden floorboard, and cane chair. Magritte's pictures are full of images of torn, splintered, broken, pierced or cut-out forms.

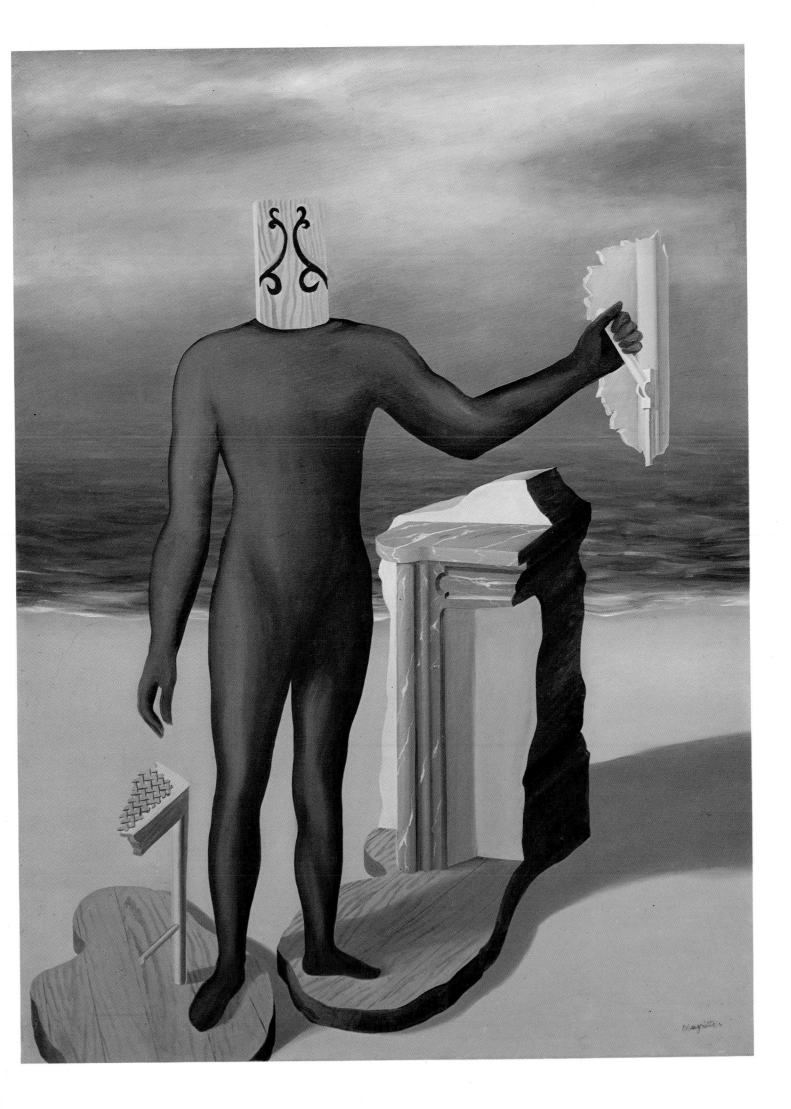

The Threatened Assassin/L'assassin menacé

OIL ON CANVAS, 150.5 × 192.7 CM. 1927. NEW YORK, THE MUSEUM OF MODERN ART

The origin of the bowler-hatted man in Magritte may well have been a work by Max Ernst, *Pietà or Revolution by Night*, 1923 (Fig. 20), which was illustrated in the issue of *La Révolution Surréaliste* for July 1925. The moustached father figure in Ernst's painting was in turn based on de Chirico's portrayal of his own father in *The Child's Brain*, 1914. Following de Chirico, Ernst represents each of the three figures in *Pietà* as either asleep, dead or in a trance. This may allude to the sessions in which the Surrealists, including Ernst, tried to release stream-of-consciousness imagery while under the influence of drugs or hypnosis. Although this 'automatic' aspect of Surrealism was of little interest to Magritte, he habitually painted figures with eyes closed or staring in a trance-like way. His paintings of 1926–7, which make use of the theatrical space and lighting of de Chirico's Metaphysical interiors, are especially reminiscent of dream imagery.

The convention, common to Christian art, of representing a child in the arms or on the knees of its parent is given a specifically Freudian twist by Ernst. It is taken up by Magritte in *The Spirit of Geometry* (Fig. 3), where the relationship is inverted, and in the drawing that he contributed to the book *Violette Nozières* (Fig. 14).

One of the principal sources for *The Threatened Assassin* was Magritte's enthusiasm for popular crime and horror fiction, such as the *Fantômas* series, a passion he shared with other Surrealists. Robert Desnos, for example, singled out *Fantômas* for special attention in an article on 'Modern Imagery', in *Documents* 7, December 1929. The macabre covers for these cheap adventure and mystery stories found their way into certain details of Magritte's paintings, and *The Threatened Assassin* itself may actually have been inspired by a particularly melo-

dramatic scene from Louis Feuillade's film *Fantômas* of 1913. An atmosphere of violence and suspense is also to be found in Ernst's collage-novel, *La Femme 100 Têtes* of 1929 (Fig. 19). The page shown here was reproduced in the December 1929 issue of *Variétés*, the Belgian magazine with which Magritte was associated. The running figure clasps a suitcase to which is strapped a severed arm similar to the 'club' held by one of the bowler-hatted men in the painting.

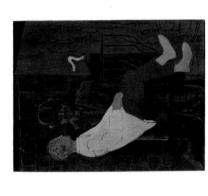

Fig. 20
MAX ERNST
Pietà or Revolution by Night
OIL ON CANVAS, 116 × 88.9 CM. 1923. LONDON, TATE GALLERY

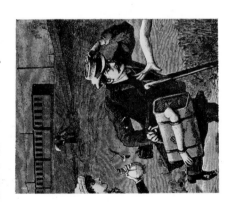

Fig. 19
MAX ERNST
Collage in 'La Femme 100 Têtes'
1929. ILLUSTRATED IN 'VARIÉTÉS', DECEMBER 1929

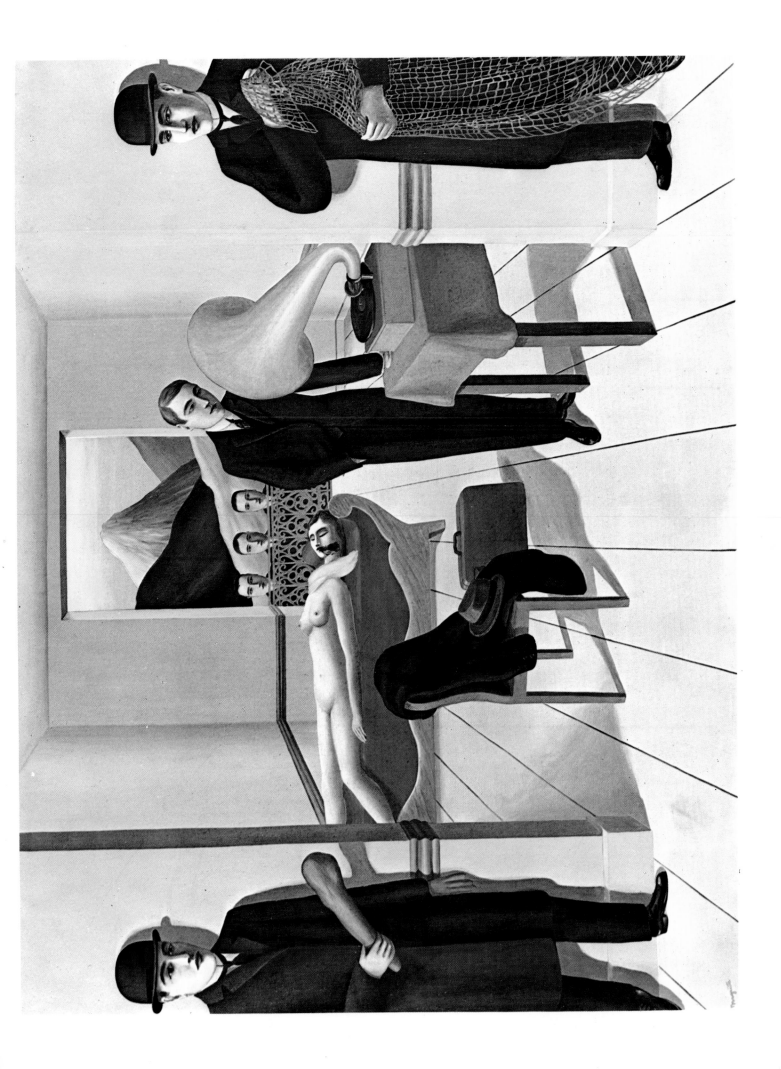

The Secret Player/Le joueur secret

OIL ON CANVAS, 152 × 195 CM. 1927. KNOKKE, NELLENS COLLECTION

Although he mistrusted psychoanalysis, believing that his own art dealt not in symbols or ideas but in images which were the product of inspired thought, a number of Magritte's pictures nevertheless contain objects that closely correspond to certain types of dream imagery identified by Freud. In his *Introductory Lectures on Psychoanalysis* (1916–17), Freud lists a whole range of sexual symbols for the male genitals, including 'balloons, flying machines and . . . Zeppelin airships'. Dreams of flying, he says, are often 'dreams of general sexual excitement' and are common to both sexes. Other male sexual symbols cited by Freud are explicitly phallic shapes such as umbrellas, sticks and trees; weapons of all kinds; and certain reptiles and fish.

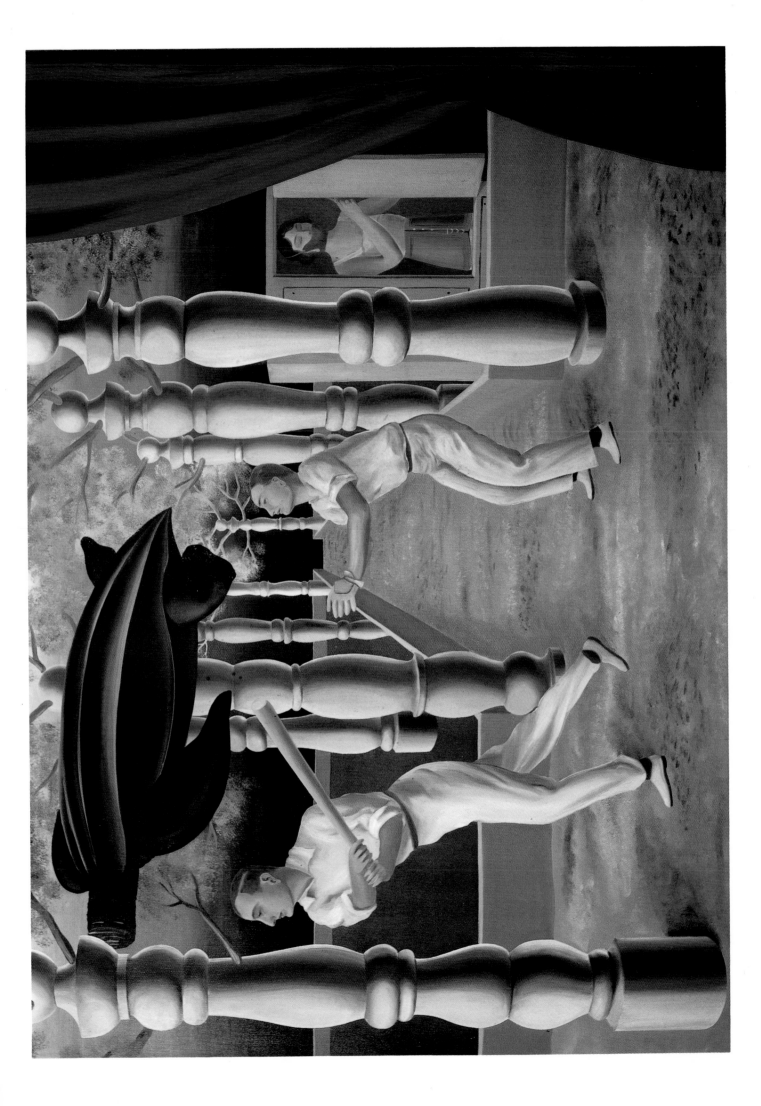

Midnight Marriage/Le mariage de minuit

OIL ON CANVAS, 139.5 × 105.5 CM. 1926 OR 1927. BRUSSELS, MUSÉES ROYAUX DES BEAUX-ARTS DE BELGIQUE

Magritte often presents us with wilful reversals of natural law such as flying boulders, a sky made of solid cubes, or, as here, trees turned upside down. In the foreground of the picture the rear view of a male head can be seen on a display table, above a blond, curly female wig draped over its stand. Once again all identifying facial features have been banished from the painting, making it all the more disconcerting an image.

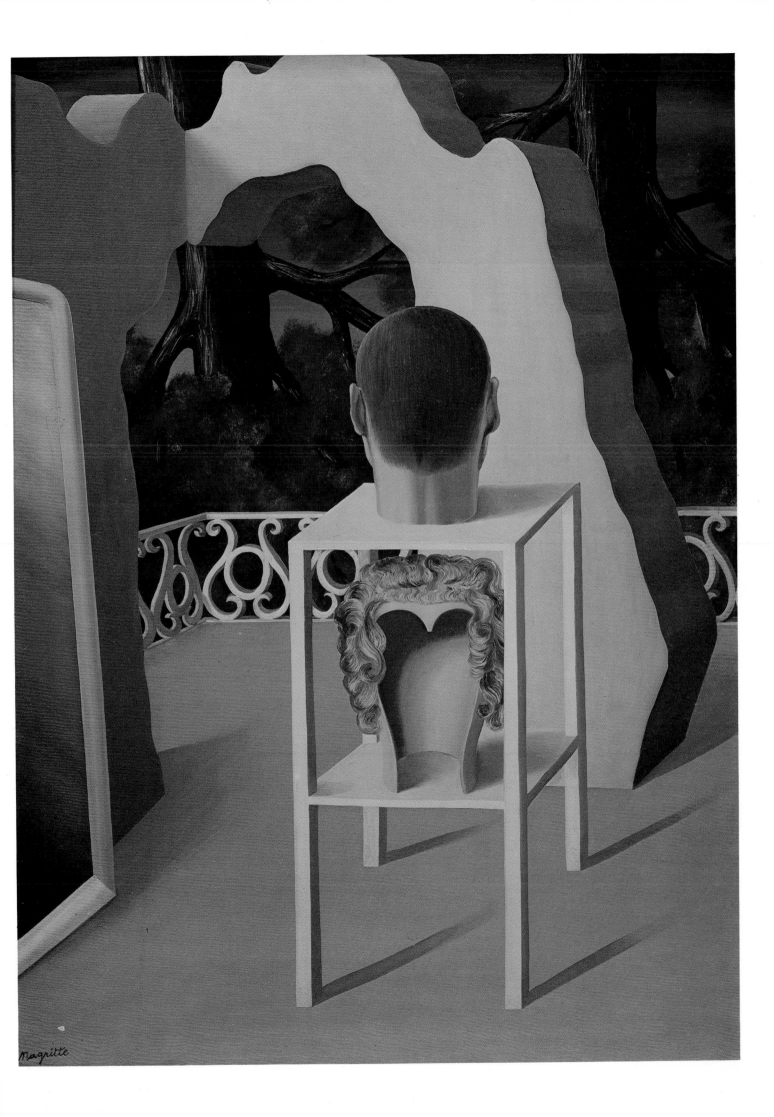

The Reckless Sleeper/Le dormeur téméraire

OIL ON CANVAS, 115 × 79.4 CM. 1927. LONDON, TATE GALLERY

This is one of the most enigmatic of all Magritte's paintings of the late twenties. The objects embedded in the molten lead relief (which resembles a work by Arp) include a lighted candle and a bowler hat, both male sexual symbols as defined by Freud. The faithful representation of wood-graining is a distinctive feature of Magritte's work of this period (compare with Plate 18). It may be worth remarking that Freud names enclosures and containers such as 'boxes, trunks, cases ... cupboards ... and ... rooms', as well as objects made from wood, as being common dream symbols for the female sex.

Freudian symbolism apart, *The Reckless Sleeper* exemplifies Magritte's habit of compartmentalizing his imagery, while the arrangement of objects recalls pictograms. The July 1929 issue of *Variétés* ran a feature on tramps illustrated with examples of their written sign language in which keys, birds, knives, hands, arrows and other symbols appear.

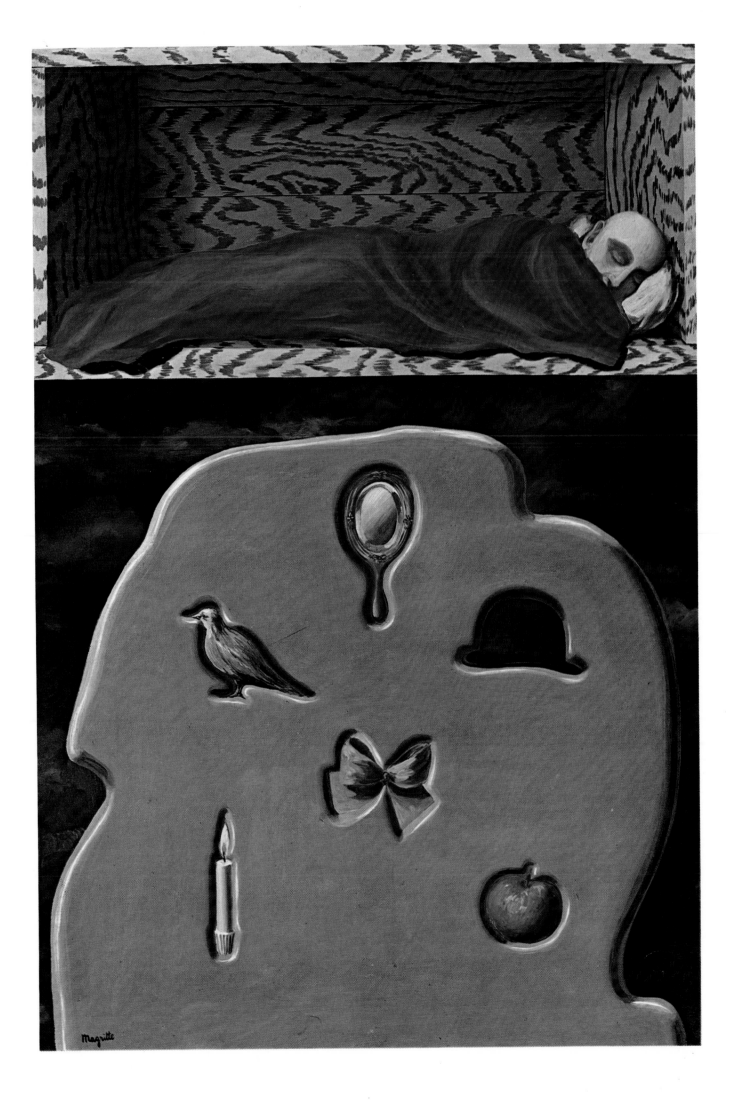

Young Girl Eating a Bird/Jeune fille mangeant un oiseau

OIL ON CANVAS, 73.5 × 97.5 CM. 1927. DÜSSELDORF, KUNSTSAMMLUNG, NORDRHEIN-WESTFALEN

That Magritte was sometimes drawn to the Surrealist obsession with death and the erotic is demonstrated by pictures such as this one and *The Threatened Assassin* (Plate 8). *Young Girl Eating a Bird* is a macabre and horrifying image suggesting loss of sexual innocence.

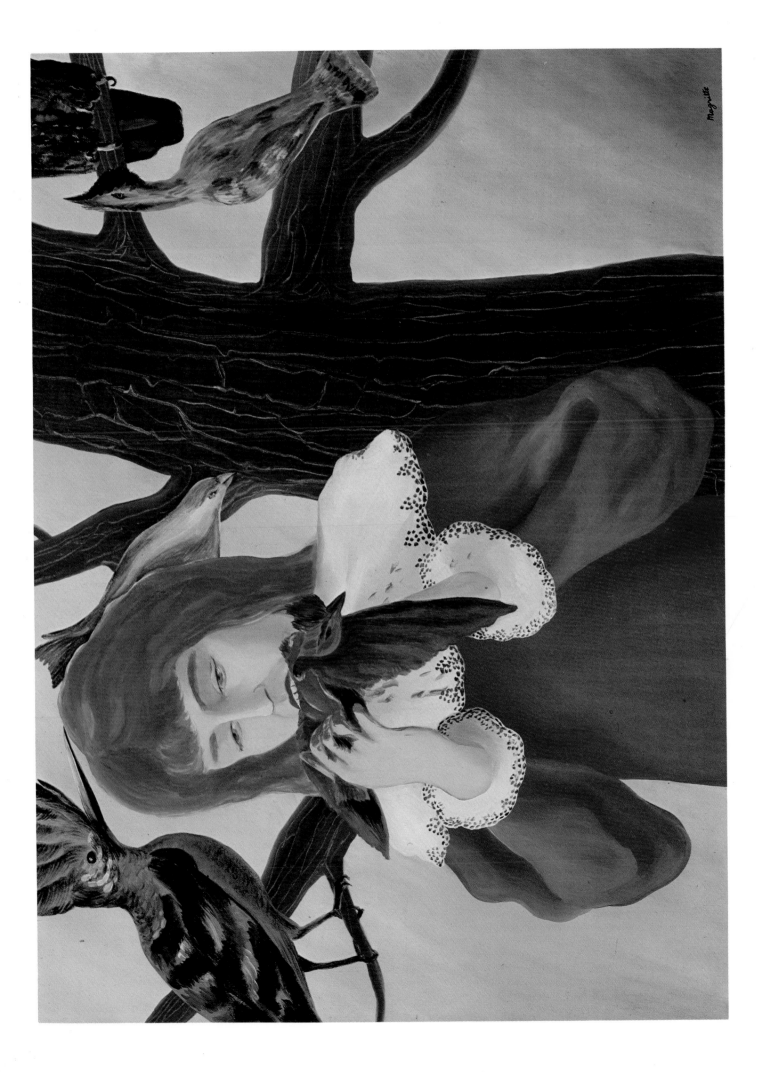

Person Meditating on Madness/Personnage méditant sur la folie

OIL ON CANVAS, 54 × 73 CM. 1928. PRIVATE COLLECTION

On the whole Magritte had little time for the bizarre or morbid subjects that intrigued his Surrealist friends in Paris, such as murder, insanity, hypnosis, and spiritualism. But the occasional picture does suggest a passing interest in such things. Illustrated articles on these themes were published in *Variétés* (including one on the famous Prinzhorn collection of art by mental patients); and the photographs (1929–30) of people and objects by Magritte's friend Paul Nougé, the founder of Belgian Surrealism, have a nervous quality which often seems to border on hysteria.

The Double Secret/Le double secret

OIL ON CANVAS, 114 × 162.5 CM. 1927. PARIS, MUSÉE NATIONAL D'ART MODERNE, CENTRE GEORGES POMPIDOU

This is another painting that demonstrates the influence of collage on Magritte's work. The right-hand face has been replaced by a view of jingle bells, while the part that has been cut away appears alongside, so that both positive and negative shapes are depicted.

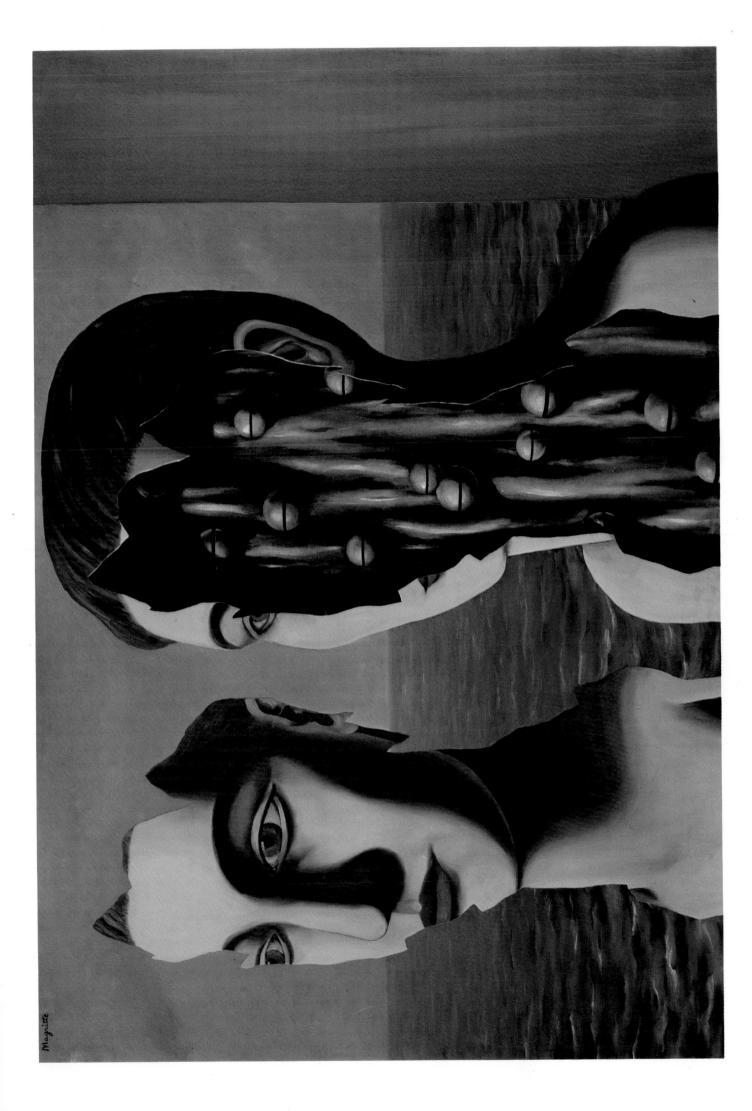

Familiar Objects/Les objets familiers

OIL ON CANVAS, 81 × 115.5 CM. 1928. PRIVATE COLLECTION

Even when we are allowed to glimpse the faces of Magritte's figures, their expressions are often as neutral and inconspicuous as their clothes and hairstyles. As in polyphysiognomic portraits, the upper half of a man is shown from five different angles, two of which are almost identical. In front of the eyes of each figure, in one case hiding them completely, float ordinary everyday objects. But compared to the figures, the objects are unique individuals: it is man who is portrayed as impersonal and mass-produced.

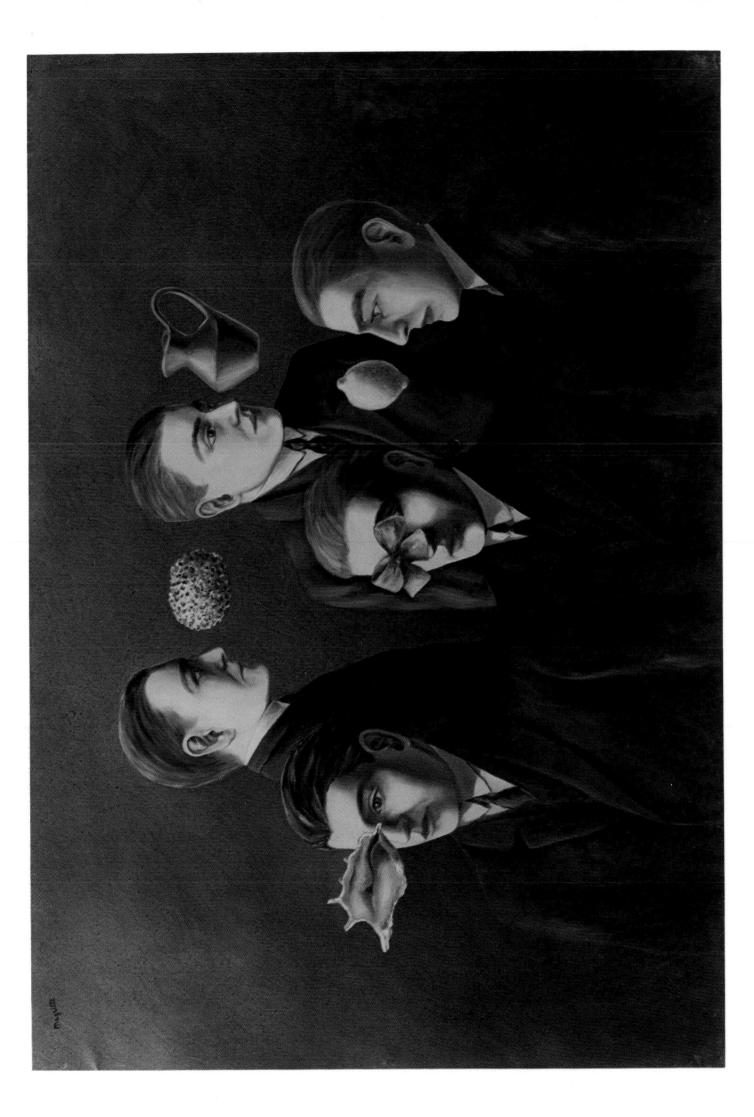

Intermission/Entracte

OIL ON CANVAS, 114.3 × 161 CM. 1927. PRIVATE COLLECTION

These severed limbs behaving like intact human figures are reminiscent of the grotesque creatures that populate the paintings of the Flemish Old Masters, which Magritte would have seen in the museum in Brussels. There is also a hint of the biomorphic imagery of Arp, whose influence is discernible elsewhere in Magritte's early work.

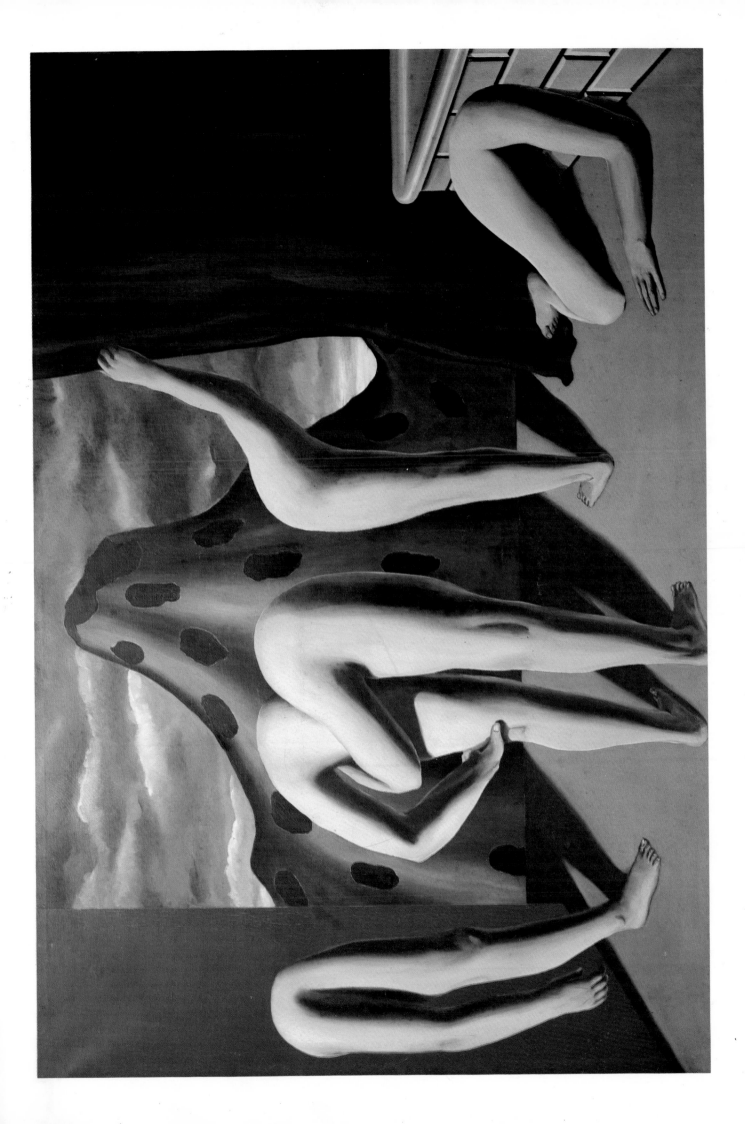

The Celestial Muscles/Les muscles célestes

OIL ON CANVAS, 54 × 73 CM. 1927. PRIVATE COLLECTION

A small number of Magritte's paintings of the late twenties employ abstract configurations which suggest the automatic techniques of Ernst, as found in *The Horde* (Fig. 21), and the works of other Surrealists. In *The Celestial Muscles*, however, the picture's strongest debt is to collage: Magritte paints irregular shapes exactly as if they have been torn or cut from paper.

Fig. 21
MAX ERNST
The Horde

OIL ON CANVAS, 115 × 146 CM. 1927. AMSTERDAM, STEDELIJK MUSEUM

Discovery/Découverte

OIL ON CANVAS, 65 × 50 CM. 1927. PRIVATE COLLECTION

Magritte was a master of metamorphosis. Here we see a woman's body transforming itself into a block of wood. The effect of such unusual changes in material and texture is shocking. As with *The Submissive Reader* (Plate 20), the source for this picture may have been an erotic postcard.

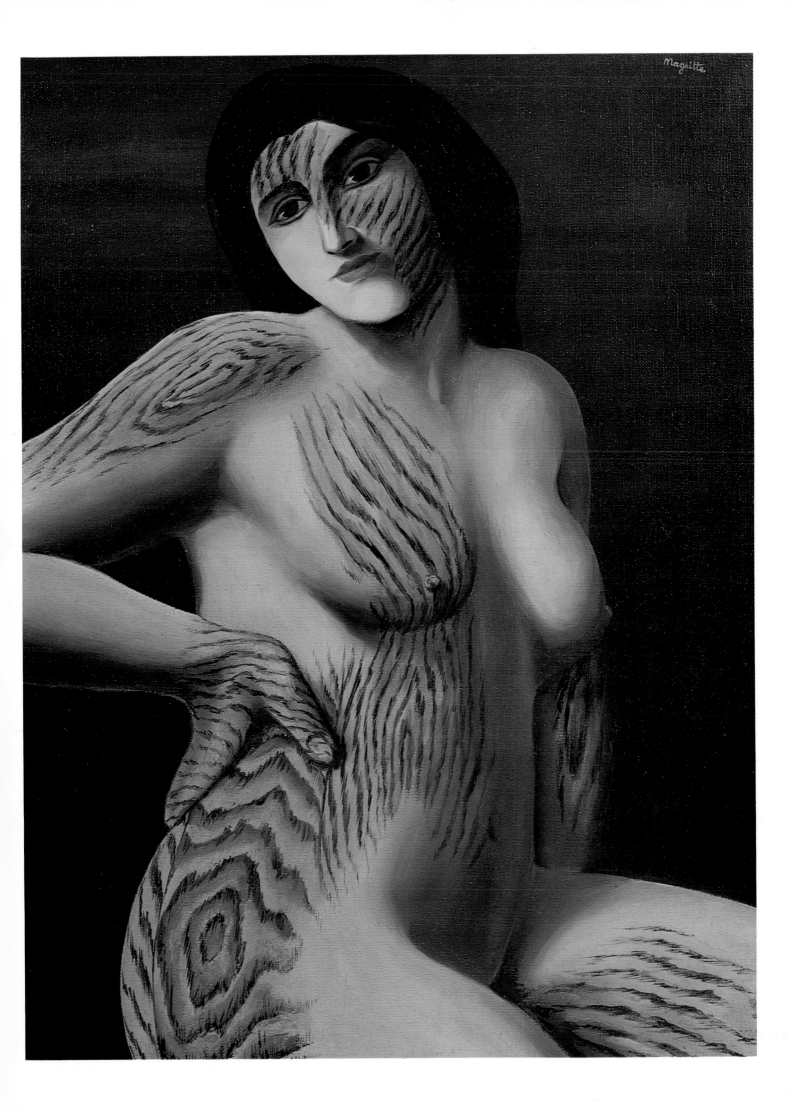

The Heart of the Matter/L'histoire centrale

OIL ON CANVAS, 116 × 81 CM. 1928. RHODE-ST-GENÈSE, MABILLE COLLECTION

The sinister hooded figure should be compared with *The Lovers* (Plate 23), another work in which the head is shown shrouded in cloth. The presence of the tuba and suitcase is inexplicable, although the former reappears in several works.

The Submissive Reader/La lectrice soumise

OIL ON CANVAS, 92 × 73 CM. 1928. PRIVATE COLLECTION

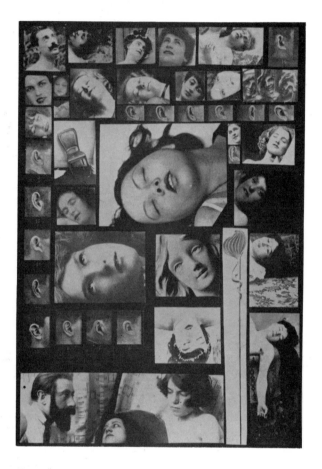

Postcards were a popular source of imagery with the Surrealists, especially those which had comic, erotic or bizarre subjects. Salvador Dalí and the poet Paul Eluard both owned substantial collections — Eluard's was featured in the Surrealist review *Minotaure* (December 1933). The same issue also included this collage by Dalí (Fig. 22), which combines photographs of hysterical girls from the clinical records of Freud's mentor, Charcot, with tantalizing fragments of pornographic postcards. In a similar way, Magritte's picture *The Submissive Reader* was based on the upper half of a postcard showing a girl in an ecstatic state reading what is presumably an erotic novel.

Fig. 22
SALVADOR DALÍ
The Phenomenon of Ecstasy
COLLAGE IN 'MINOTAURE', NOS. 3–4, 1933

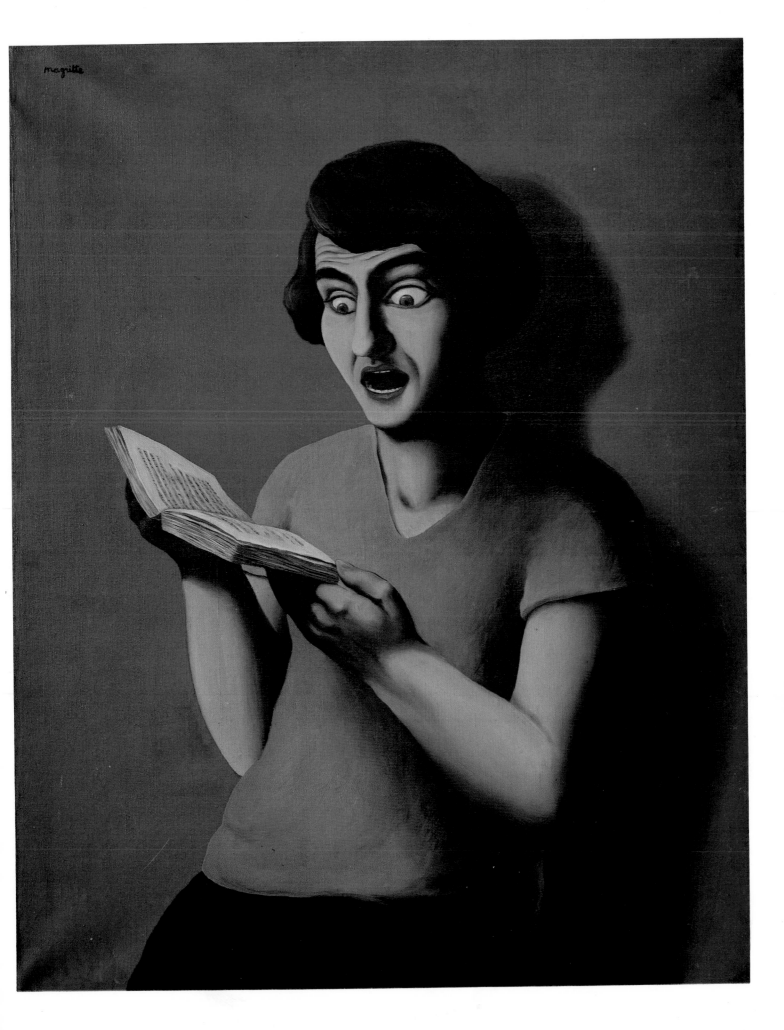

Titanic Days/Les jours gigantesques

OIL ON CANVAS, 92 × 73 CM. 1928. PRIVATE COLLECTION

Magritte's use of the collage idea here is as violent and dramatic as his subject: a sexual assault. Superimposed like a shadow on the female victim, whose shape recalls Picasso's monumental classical bathers of the twenties, is part of her aggressor's body. The figure of the man is 'cut' to fit exactly the outline of the woman. A drawing of this work was reproduced in the third issue of *Distances* (April 1928), the little magazine started by Paul Nougé to which Magritte, Scutenaire and other Belgian Surrealists contributed.

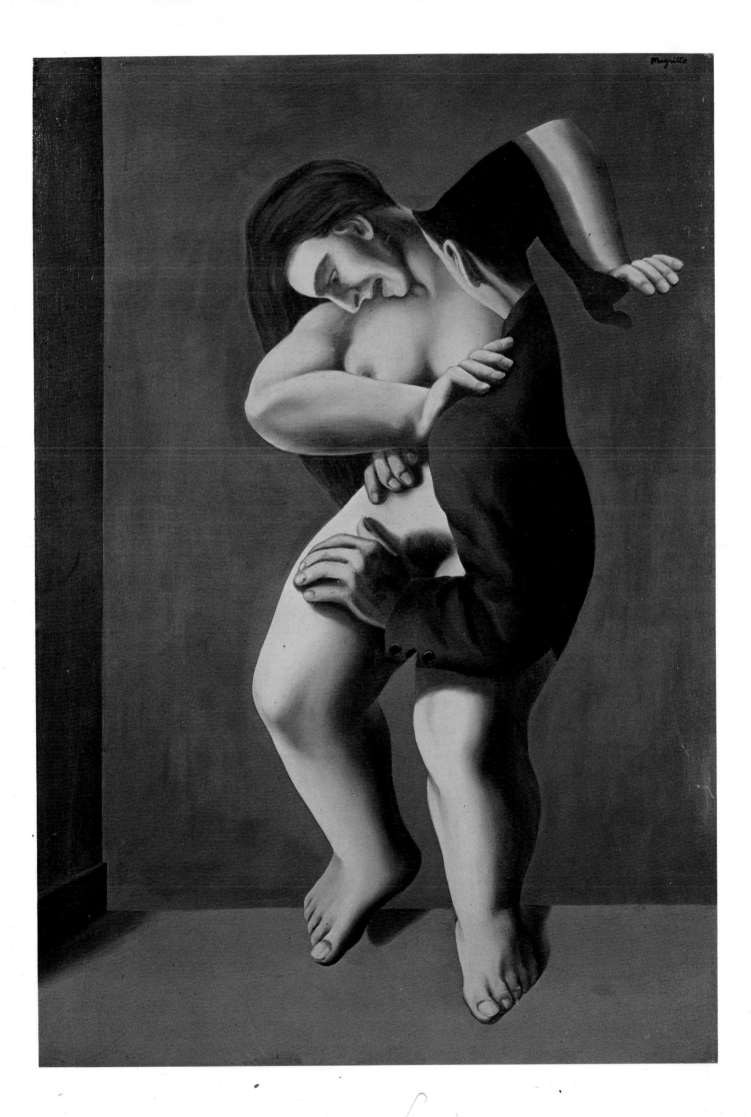

The Hunters at the Edge of Night/Les chasseurs au bord de la nuit

OIL ON CANVAS, 81 × 115.7 CM. 1928. PRIVATE COLLECTION

Alarming psychological states such as panic, claustrophobia, and fear are often represented in Magritte's pre-war work, but depicted in a cool, unemotional style which only emphasizes their extreme nature. In this painting the central hunter has no head (compare with Plate 37 and Fig. 38), while his cowering companion shields his face from view. The cause of their distress, however, remains obscure.

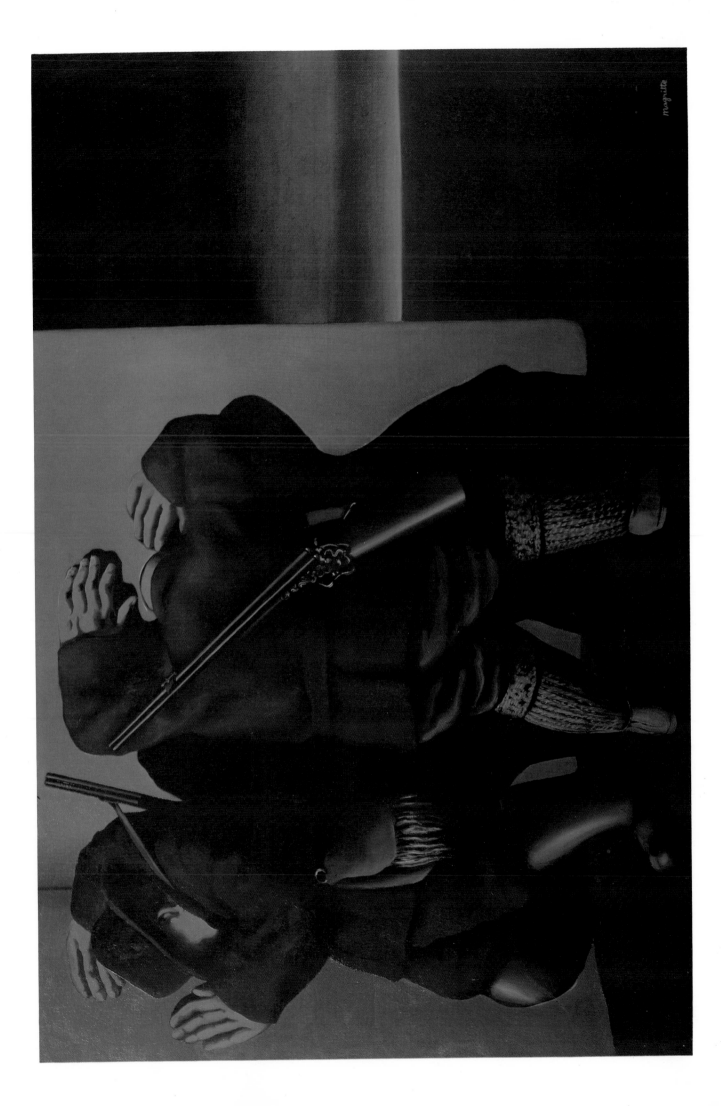

The Lovers/Les amants

OIL ON CANVAS, 54.2 × 73 CM. 1928. NEW YORK, RICHARD S. ZEISLER COLLECTION

Magritte developed a range of devices for hiding or obliterating the faces of his subjects, as if to question their identity. This image was used again for the cover of *Variétés*, January 1929 (Fig. 23). The shrouded head, reminiscent of veiled figures in fifteenth-century Flemish painting, may have had a more direct source in the myth surrounding the suicide of Magritte's mother, whose face was supposed to have been covered by her nightdress when her body was fished out of the River Sambre on 12 March 1912.

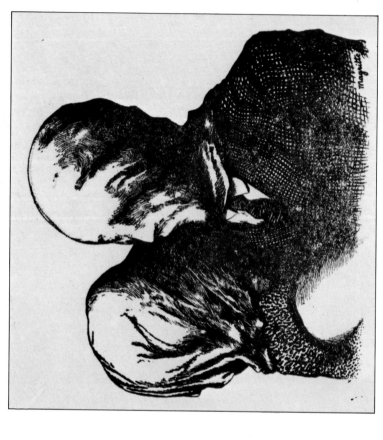

Fig. 23
Detail from the Cover for 'Variétés'
BRUSSELS, JANUARY 1929

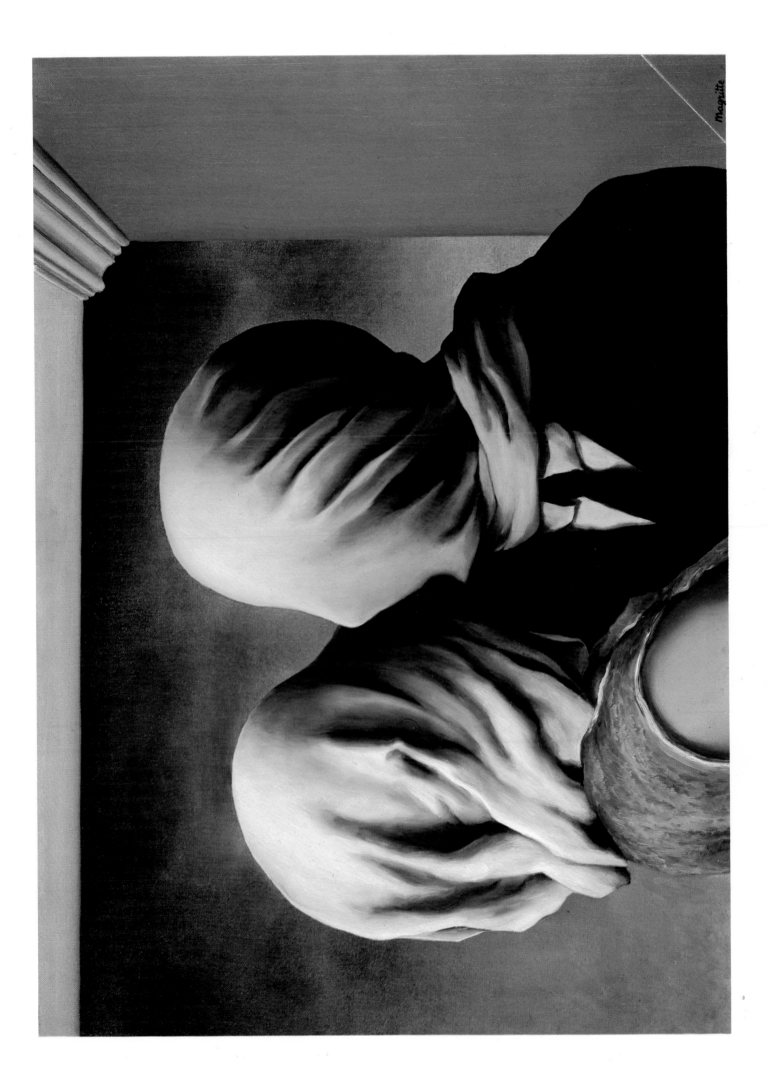

A Courtesan's Palace/Le palais d'une courtisane

OIL ON CANVAS, 53.5 × 72 CM. 1928. PRIVATE COLLECTION

The idea of isolating a segment of the female nude body is one that Magritte explores in several works, either as a picture within a picture, a framed, shaped canvas or a more sculptural object (Fig. 25). The torso is sometimes broken down further into separate interlocking parts out of scale with one another. In 1967 Magritte modelled a sculpture on this theme which was cast in bronze after his death.

The worrying image of a trunk divorced from head and limbs had appealed earlier in the century to Eugène Atget, some of whose photographs of Parisian shop-windows were reproduced in *Variétés* (Fig. 24) and other Surrealist periodicals.

Fig. 25
The Progress of Summer
OIL ON CANVAS, 60.8 × 73.2 CM. 1938 OR 1939. PRIVATE COLLECTION

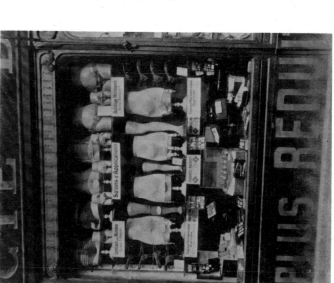

Fig. 24
EUGÈNE ATGET
Photograph of a Shop-Window
ILLUSTRATED IN 'VARIÉTÉS', JANUARY 1930

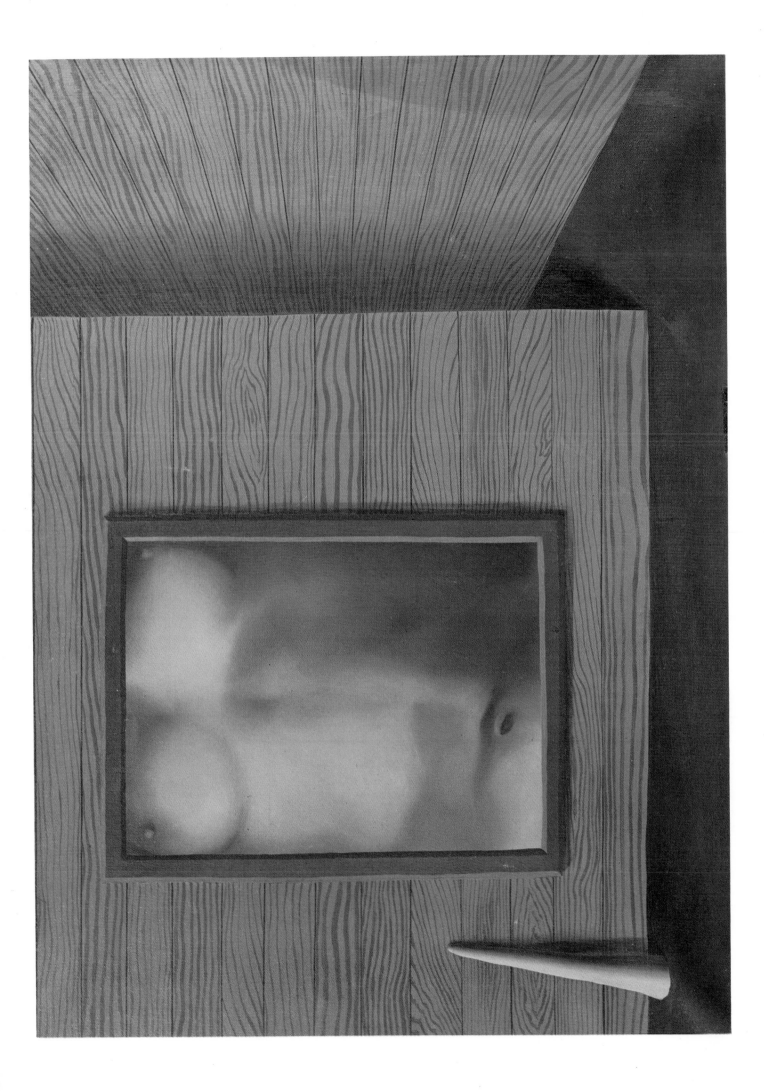

On the Threshold of Liberty/Au seuil de la liberté

OIL ON CANVAS, 115.2 × 147 CM. 1930. ROTTERDAM, MUSEUM BOYMANS — VAN BEUNINGEN

This extraordinary painting shows Magritte dividing his imagery into separate panels or compartments in order perhaps to call into question both the notion of painting as a window on the world, and conventional pictorial ideas such as composition and perspective. As has been noted already, the picture within a picture is frequently exploited by Magritte for its ambiguous associations.

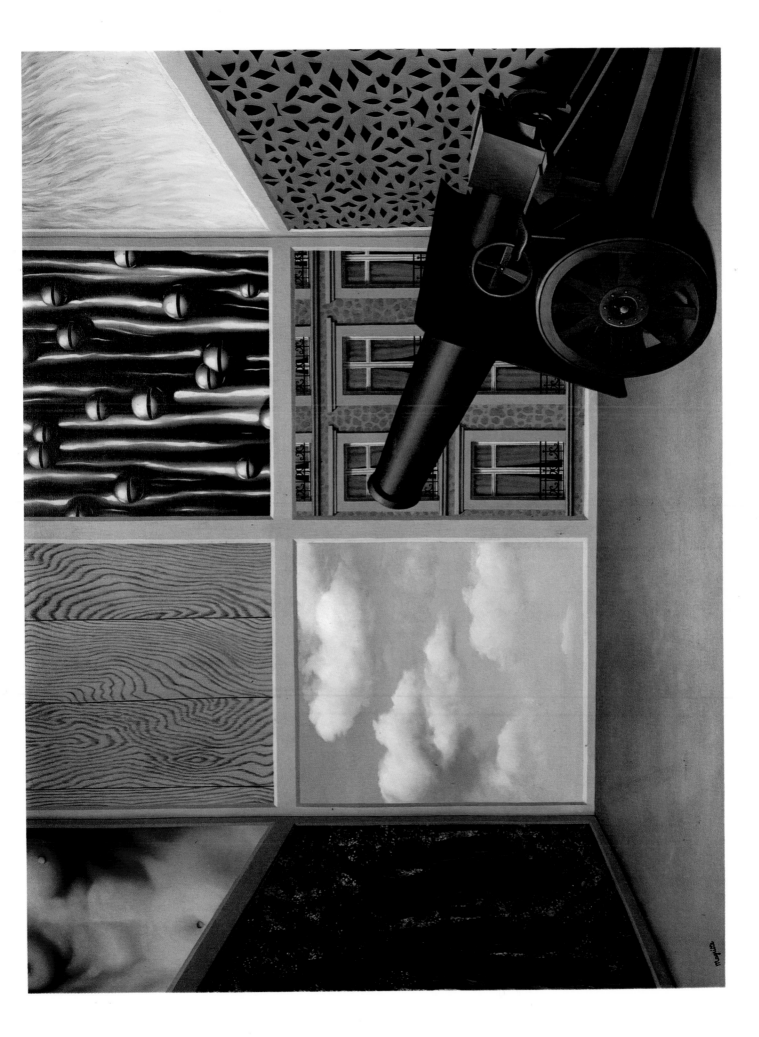

The Use of Speech/L'usage de la parole

OIL ON CANVAS, 54.5 × 73 CM. 1928. COLOGNE, GALERIE RUDOLF ZWIRNER

Fig. 27
JOAN MIRÓ
This is the Colour of my Dreams

OIL ON CANVAS, 96 × 130 CM. 1929. PRIVATE COLLECTION

The introduction of words into Magritte's pictures in the late twenties often seems, as here, to parody Miró (Fig. 27), although the intention is quite different. Whereas Miró, Masson and other Surrealists were interested in automatic writing — in free, spontaneous calligraphy divorced from logical thought — Magritte was concerned to scrutinise the arbitrary, shifting relationship between objects, images and names. He set out his thoughts on language and representation in a short illustrated text, 'Words and Images', which was published in *La Révolution Surréaliste*, No. 12 (December 1929). 'Sometimes the name of an object can replace an image', he wrote; and later, 'A nondescript form can often replace the image of an object'. Several drawings illustrating these and related ideas were published in *Variétés* between 1928 and 1930 (Fig. 26).

Fig. 26
Drawing in 'Variétés'
DECEMBER 1929

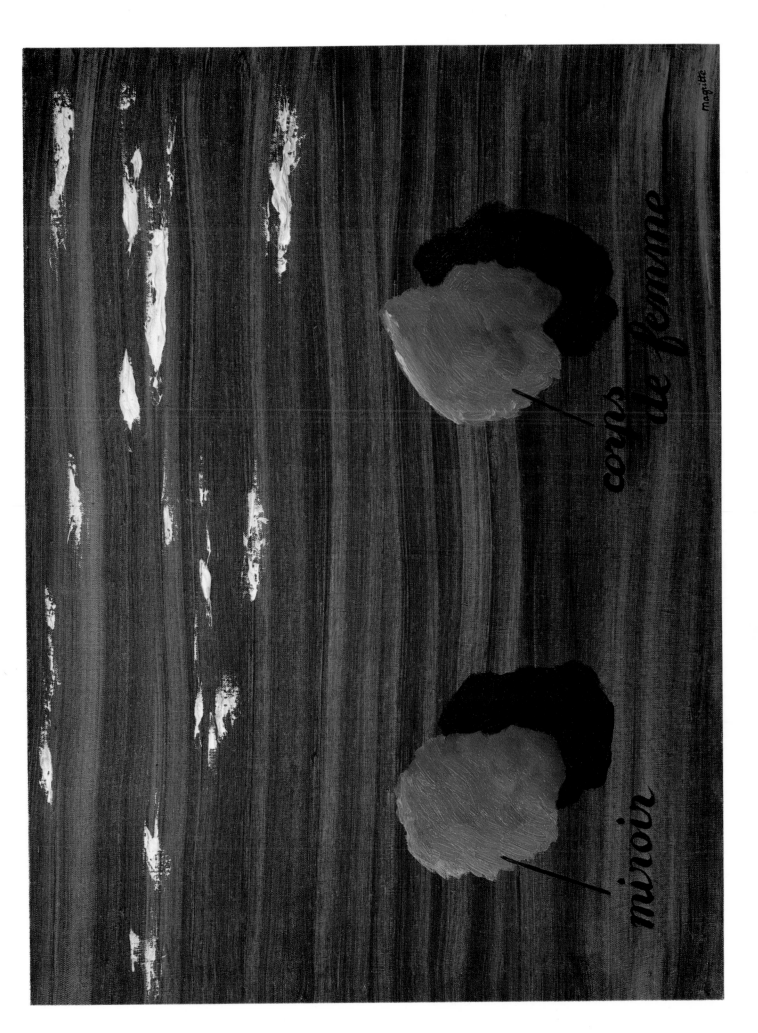

miroir

corps de femme

magritte

The Empty Mask/Le masque vide

OIL ON CANVAS, 73 × 92 CM. 1928. DÜSSELDORF, KUNSTSAMMLUNG NORDRHEIN-WESTFALEN

The two versions of *The Empty Mask* (Plate 27 and Fig. 28) form part of a reflection on the complexities inherent in our conventional methods of describing the real world. A couple of sentences from Magritte's programmatic text 'Words and Images' may be relevant:

> A word can replace an object in reality.
> An object never performs the same function as its name or its image.

In these two pictures Magritte is also beginning to challenge the received idea that the painter should seek to represent reality in a square or rectangular format, a problem he would try to solve in later works.

In the small drawing from *Variétés* (Fig. 29) Magritte demonstrates his absurdist, tongue-in-cheek proposition that 'an object is not so attached to its name that we cannot find a more suitable one for it'.

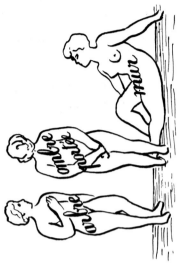

Fig. 29
Drawing in 'Variétés'
DECEMBER 1929

Fig. 28
The Empty Mask
OIL ON CANVAS, 81.3 × 116.2 CM. 1928. CARDIFF, NATIONAL
MUSEUM OF WALES

The Magic Mirror/Le miroir magique

OIL ON CANVAS, 73 × 54 CM. 1929. PRIVATE COLLECTION

Magritte and Dali (Fig. 31) were for a time directly influenced by the soft biomorphic forms of Arp's sculptures and wooden reliefs, which can be read simultaneously as figurative and abstract. In both *The Magic Mirror* and Magritte's drawing of a 'person laughing' (Fig. 30) the affinity between the free organic shape and its 'name' is closer than in other works which incorporate words, since it has a distinct, anthropomorphic presence. Magritte's paintings of this period are like naked statements — simple, bold, frontal — which in a curious way seem to anticipate Minimal art.

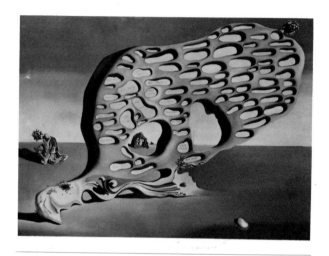

Fig. 31
SALVADOR DALÍ
The Enigma of Desire
OIL ON CANVAS, 110 × 150 CM. 1929. MUNICH, BAYERISCHE STAATS-GEMÄLDESAMMLUNGEN

Fig. 30
Drawing in 'Variétés'
DECEMBER 1929

The Eternal Evidence/L'évidence éternelle

OIL ON FIVE FRAMED CANVASES, MOUNTED ON PERSPEX, 22 × 12, 19 × 24, 27 × 19.5, 22 × 16, 22 × 12 CM. 1930. HOUSTON, MENIL FOUNDATION COLLECTION

Just as Magritte plays games with language, he also depicts woman as a jigsaw puzzle or game of 'head, body and legs' — a favourite with the Surrealists, examples of which were reproduced in the June 1929 issue of *Variétés*. The framing of the body in sections, a practice Magritte adopts in other works, underlines the picture's status as a painted representation (Fig. 33), an illusion, rather than the real thing. Magritte's women are often difficult to piece together or are shown camouflaged or in hiding (Fig. 32).

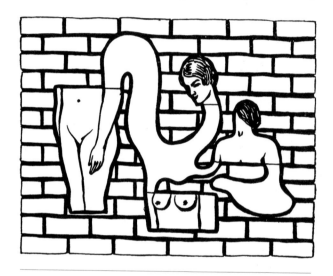

Fig. 32
The Acrobat's Repose
DRAWING. FEBRUARY 1928. ILLUSTRATED IN 'DISTANCES', NO. 2, MARCH 1928

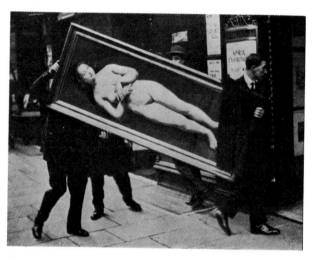

Fig. 33
Photograph in 'Variétés'
DECEMBER 1929

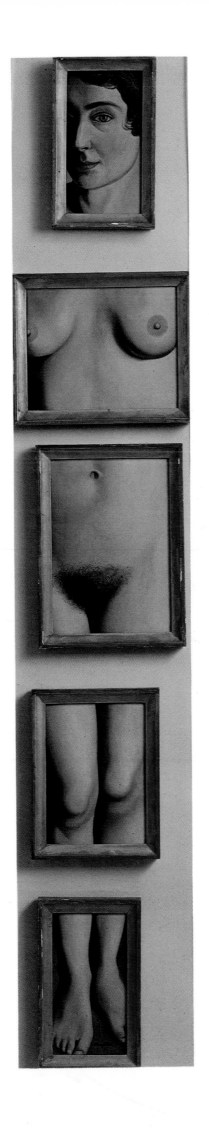

The Betrayal of Images/La trahison des images

OIL ON CANVAS, 62.2 × 81 CM. 1929. LOS ANGELES COUNTY MUSEUM OF ART

The final stage in the argument between language and the material world is reached when words are made to contradict, rather than act as a substitute for, the object. 'This is not a pipe': it is a two-dimensional painted image of a pipe, a representation. Do not trust the artist, Magritte appears to be saying, and perhaps he was thinking along similar lines when, years later, he admitted: 'I particularly like the idea that my paintings say *nothing*.'

Magritte reversed the process in 1936 or 1937 when he painted a tiny picture of a slice of Camembert, framed it, placed it on a cheese dish under a transparent glass dome and entitled the whole object *This is a piece of cheese*. Much of Magritte's work is concerned to make us aware of the ambiguities and inconsistencies in our conception of reality. The briar pipe, with its clean lines and simple form dictated by use, was held up as a model by Le Corbusier (Fig. 5); but it has recently

been suggested by Silvano Levy that the most likely source for *The Betrayal of Images* was a new pipe shop which opened in Brussels in 1927. Above the first-floor window hung a large painted pipe almost identical to the one in Magritte's picture. Seeing it could have given Magritte the idea that a pictorial symbol and a written sign are equal and interchangeable.

A shop sign may conceivably lie behind the image of the eye in Magritte's *The False Mirror* of 1929 (Fig. 34). The issue of *Variétés* for December 1928 had reproduced a still from Karl Grune's film *The Street*, which showed on optician's sign lit up at night (Fig. 35) Magritte took a keen interest in the cinema, and no issue of *Variétés* was complete without reference to the latest films or the work of avant-garde directors.

Fig. 34
The False Mirror

OIL ON CANVAS, 54.2 × 81.2 CM. 1929. NEW YORK, THE MUSEUM OF MODERN ART

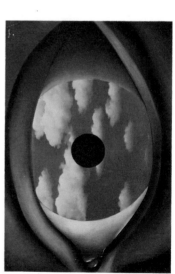

Fig. 35
Still from the Film 'The Street' by Karl Grune

ILLUSTRATED IN 'VARIÉTÉS', DECEMBER 1928

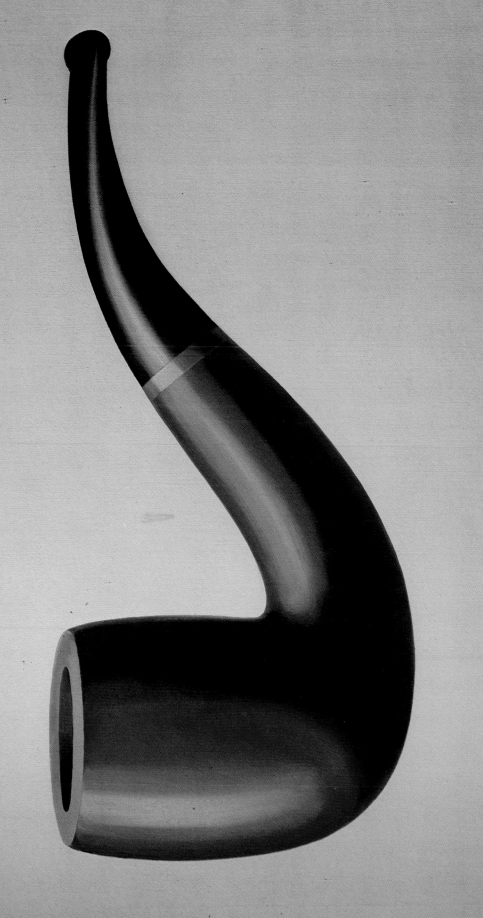

The Unexpected Answer/La réponse imprévue

OIL ON CANVAS, 81.5 × 54.1 CM. 1933. BRUSSELS, MUSÉES ROYAUX DES BEAUX-ARTS DE BELGIQUE

Magritte's paintings of the thirties are pictorial conceits, the result of flashes of insight which came to the artist (if we are to believe him) when he thought about certain objects or situations. In his autobiographical lecture 'Lifeline', delivered in 1938, Magritte said that 'the problem of the door called for an opening one could pass through. In *The Unexpected Answer*, I showed a closed door in a room; in the door an irregular-shaped opening revealed the night.'

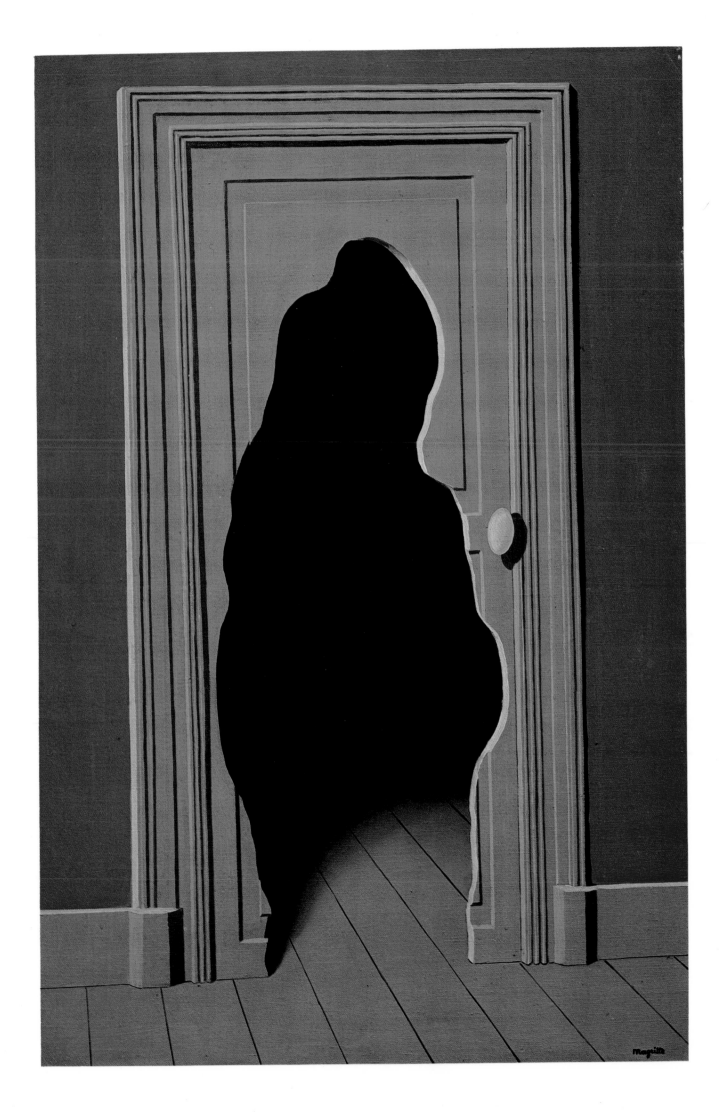

Black Magic/La magie noire

OIL ON CANVAS, 73 × 54.4 CM. 1933 OR 1934. MME E. HAPPÉ-LORGE COLLECTION

There are a number of versions of this picture, in which a statue is shown in the process of transforming itself into a woman, or vice versa — it is deliberately ambiguous. To complicate matters further, the petrified upper half of the woman's body is painted in the same blue as the sky. The living statue has a long history in Surrealist art, going back to Ernst's *Pietà* (Fig. 20), in which the artist portrays himself as a classical statue in his father's arms, and ultimately to de Chirico.

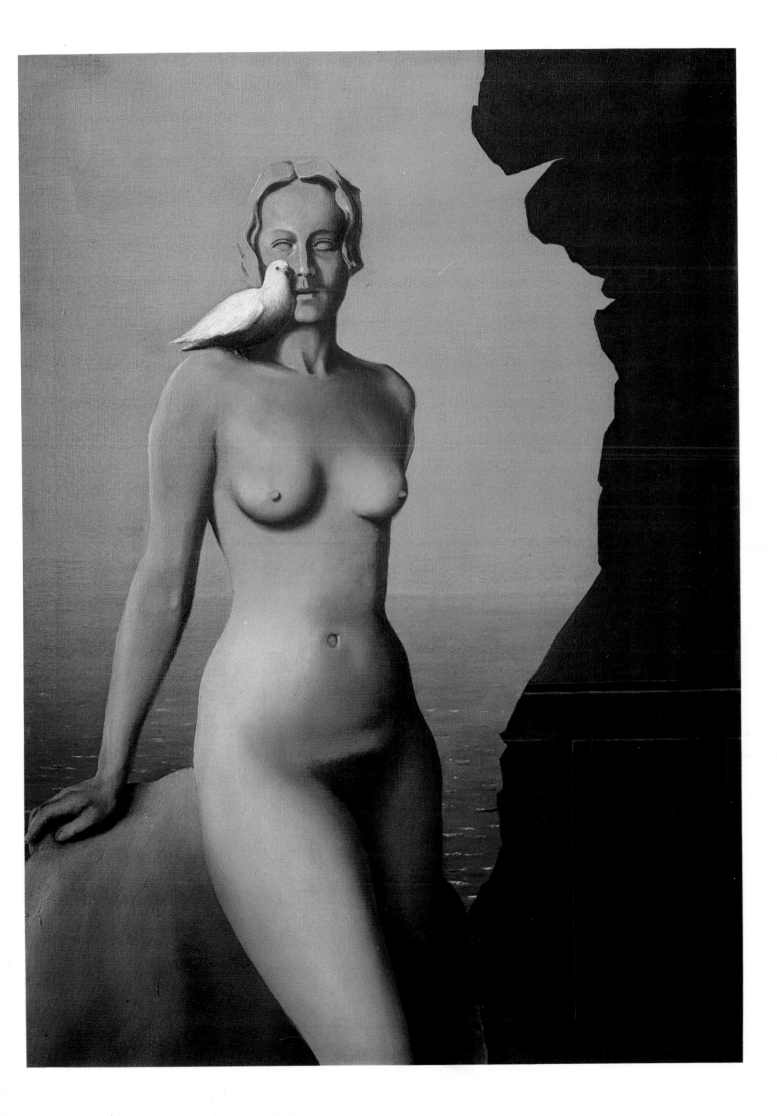

The Human Condition/La condition humaine

OIL ON CANVAS, 100 × 81 CM. 1933. PRIVATE COLLECTION

This is probably the most famous of all Magritte's pictures in which the distinction between illusion and reality is called into question, and which, like *The Door to Freedom* (Plate 34), plays on the theme of the window or mirror. In 'Lifeline' Magritte wrote:

> In front of a window seen from inside a room, I placed a painting representing exactly that portion of the landscape covered by the painting. Thus, the tree in the picture hid the tree behind it, outside the room. For the spectator, it was both inside the room within the painting and outside in the real landscape. This simultaneous existence in two different spaces is like living simultaneously in the past and in the present, as in cases of *déjà vu*. (Quoted in Torczyner, see Bibliography.)

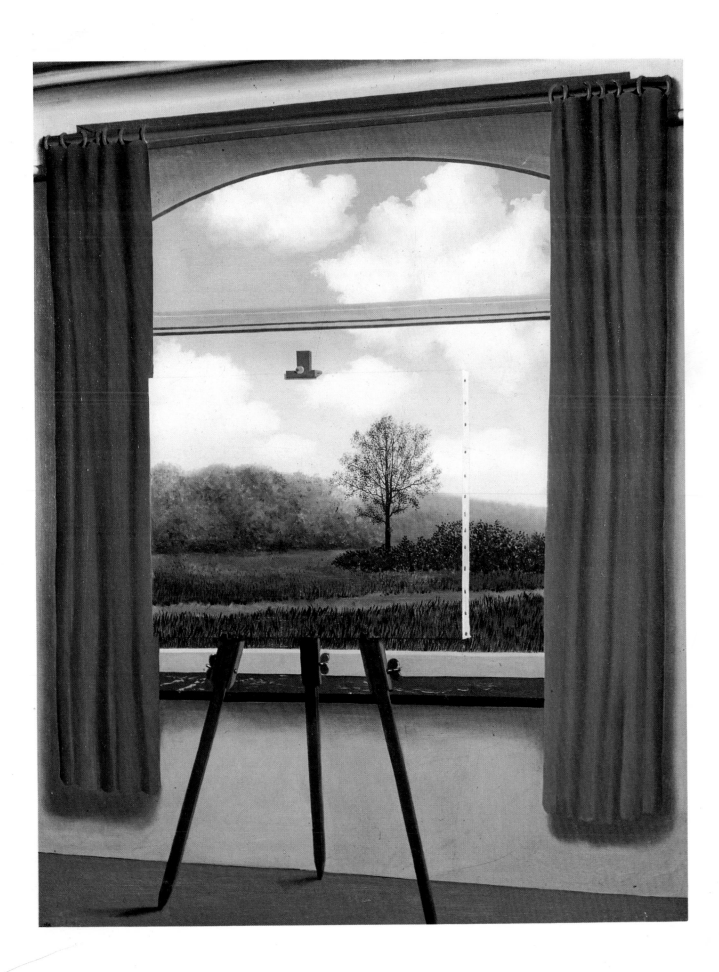

The Door to Freedom/La clef des champs

OIL ON CANVAS, 80 × 60 CM. 1936. LUGANO, THYSSEN-BORNEMISZA COLLECTION

The title of this work, *La clef des champs,* a French expression suggesting liberation from physical or mental constraint, was popular with the Surrealists. Ernst used it to title a group of collages in his 'novel' *Une Semaine de Bonté* (1934), two of which were reproduced in *Minotaure* at the end of the same year; and the phrase crops up again in 1948 at the head of an essay by André Breton on the art of the mentally ill, *L'art des fous: la clef des champs.*

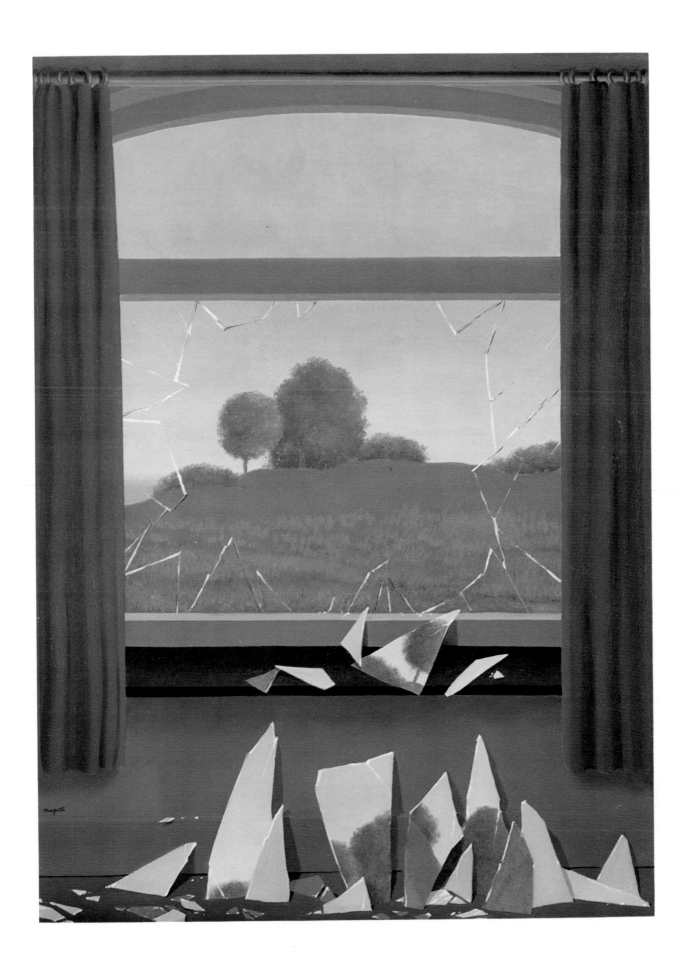

The Rape/Le viol

OIL ON CANVAS, 73.2 × 54.3 CM. 1934. HOUSTON, MENIL FOUNDATION COLLECTION

This is the most terrifying single image Magritte ever painted. Whether he had the brutally simple (but also classically Freudian) idea of transposing the sexual and facial features of a woman after seeing the photographs of freaks published in *Variétés* (Figs. 36, 37) is not known. His mind tended to work in terms of visual analogies (breasts equivalent to eyes, navel equivalent to nose, genitals equivalent to mouth), and *The Rape* belongs to a genre that includes *The Red Model* (Plate 36).

Fig. 36
'Lionel, the Man-Dog'
PHOTOGRAPH IN 'VARIÉTÉS', JULY 1929

Fig. 37
'Madame Adriana, the Bearded Lady' and 'Miss Violetta, the Trunk-Woman'
PHOTOGRAPHS IN 'VARIÉTÉS', JULY 1929

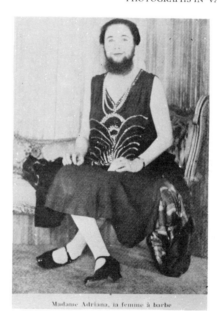

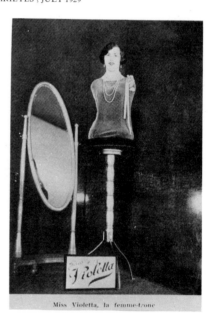

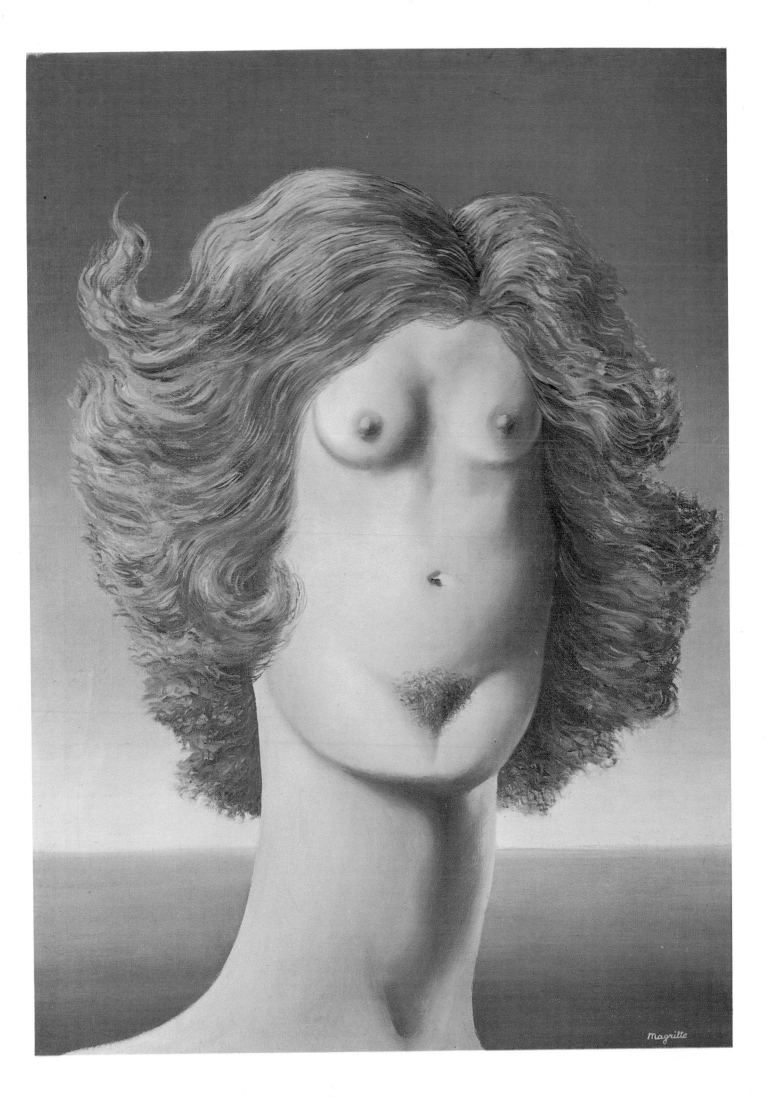

The Red Model/Le modèle rouge

OIL ON CANVAS, 183 × 136 CM. C.1937. ROTTERDAM, MUSEUM BOYMANS — VAN BEUNINGEN

Magritte's practice of marrying distinct but related objects to create a new, imaginary species which has uncomfortable overtones is brilliantly illustrated in the three versions of *The Red Model*. 'The problem of shoes', he said, 'demonstrates how the most frightening things can, through inattention, become completely innocuous. Thanks to *The Red Model*, we realise that the union of a human foot and a shoe is actually a monstrous custom.'

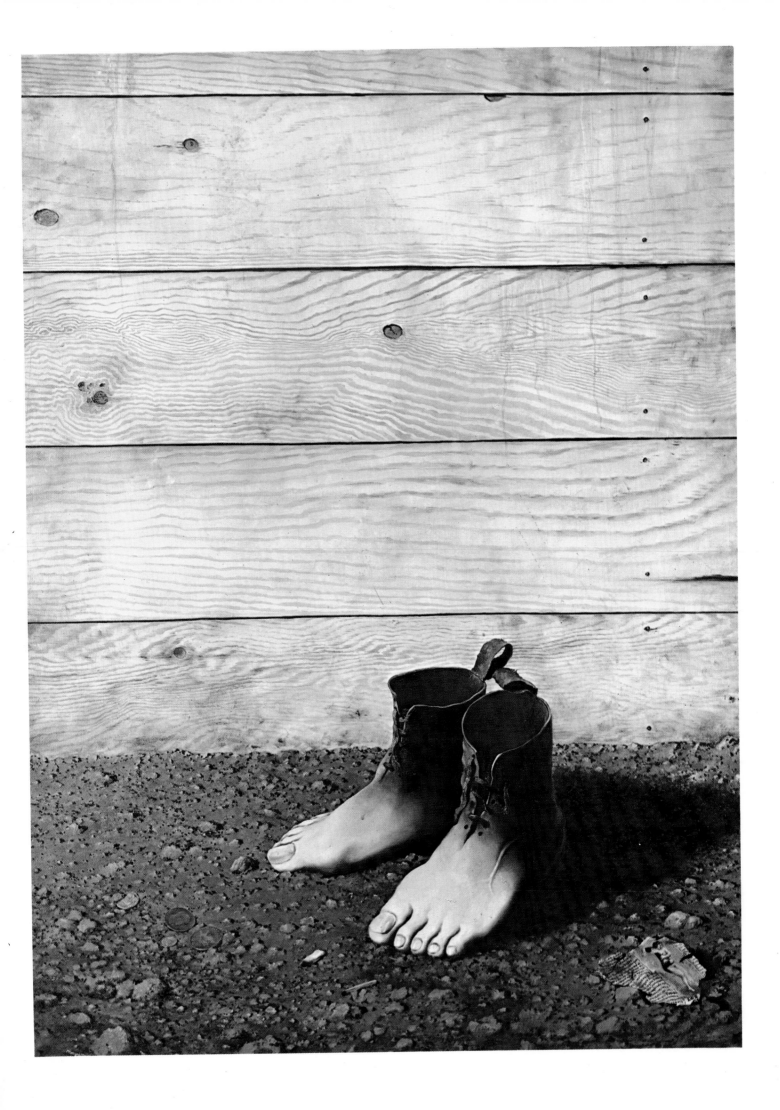

The Therapist/Le thérapeute

OIL ON CANVAS, 92 × 65 CM. 1937. BARON AND BARONESS URVATER COLLECTION

The contrast of solid and void, a motif that may stem from de Chirico, is dramatically represented in other works besides *The Therapist*: in Plates 10 and 31, for instance, an object is shown cut or hollowed out. Magritte himself once posed for one of his own photographs as the therapist, with hat, blanket, cane and unfinished painting (here replaced by the bird-cage). Trick photography of the kind reproduced in *Variétés* (Fig. 38), as well as the striking and often sinister photographs of his friend Paul Nougé, appear to have influenced Magritte's thinking. The image of the headless or decapitated figure (see Plate 22) is a common one in his work.

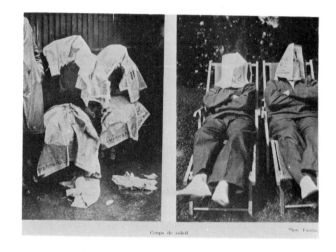

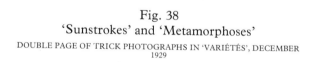

Fig. 38
'Sunstrokes' and 'Metamorphoses'
DOUBLE PAGE OF TRICK PHOTOGRAPHS IN 'VARIÉTÉS', DECEMBER 1929

Not to be Reproduced/La reproduction interdite

OIL ON CANVAS, 81.3 × 65 CM. 1937. ROTTERDAM, MUSEUM BOYMANS — VAN BEUNINGEN

Once again, Magritte resorts to a deception in order to conceal from us the true identity of his subject. The back view is in fact that of Edward James, the patron of Dalí and Magritte, who invited the latter to stay with him at his London home for a few weeks early in 1937. James owned an impressive collection of surrealist art and himself contributed articles to *Minotaure*. Magritte painted three large pictures for his house, among them a version of *The Red Model* (Plate 36), which includes some English coins on the ground.

In April 1938 Magritte was given a one-man exhibition at the London Gallery which E.L.T. Mesens was now running. The first number of the *London Gallery Bulletin* was largely devoted to Magritte's work and had a cover by him (Fig. 39).

Fig. 39
Cover for 'London Gallery Bulletin', No. 1
APRIL 1938

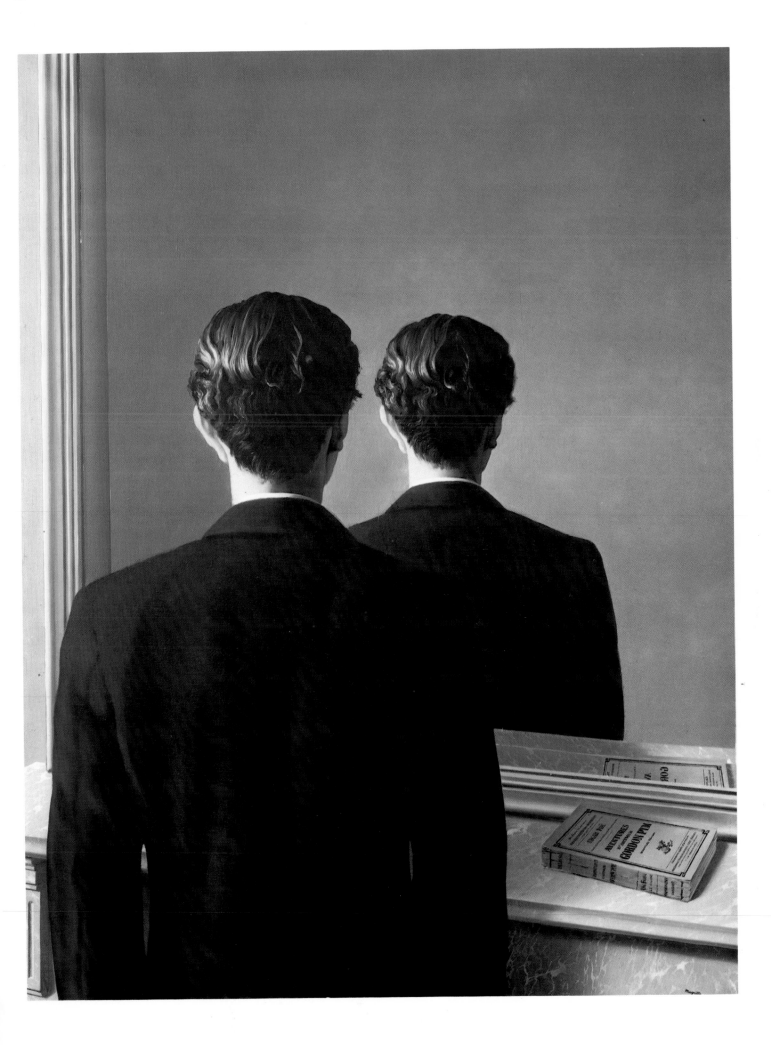

39

The Black Flag/Le drapeau noir

OIL ON CANVAS, 51.4 × 71.8 CM. 1937. EDINBURGH, SCOTTISH NATIONAL GALLERY OF MODERN ART

In his letter to André Breton of 24 June 1946, Magritte turned his back on the main tenets of Surrealism and singled out this picture as being an example of the type of dark, threatening subject of which he was no longer proud. It is possible that the image of sinister flying machines, made from coat hooks, spinning tops and other objects, was painted in response to the bombing of Guernica in the Spanish Civil War.

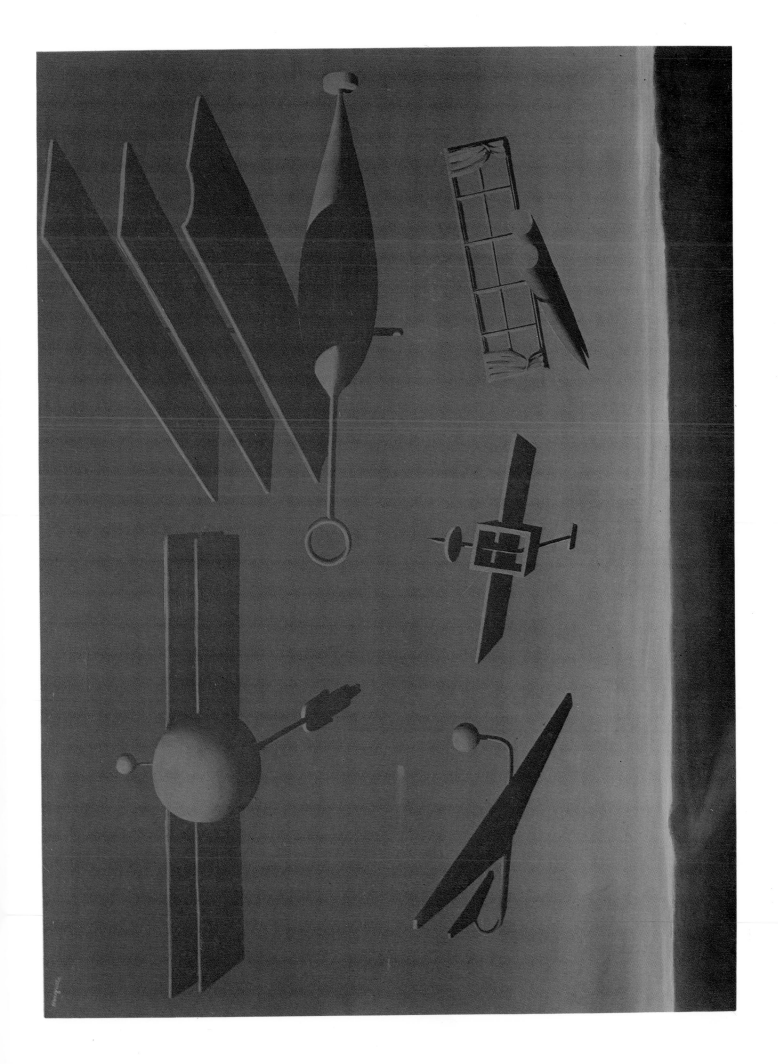

Time Transfixed/La durée poignardée

OIL ON CANVAS, 146.3 × 97.5 CM. 1939. THE ART INSTITUTE OF CHICAGO

Magritte firmly rejected all psychoanalytical explanations of this picture, maintaining that he had started out with the simple decision to paint a railway engine 'so that it would evoke mystery'. The thought then occurred to him to join the image of the engine to that of another unrelated object, a dining-room fireplace. In a letter to a friend who had said the picture reminded him of Bergson and Proust, Magritte commented:

> That does me honour and demonstrates that an image *limited strictly to its character as an image* proves the power of thought just as much as Bergson's *ideas* or Proust's *words*. *After* the image has been painted we can think of the relation it may bear to ideas or words. This is not improper, since images, ideas and words are *different* interpretations of the *same* thing: thought. (Quoted in Torczyner, see Bibliography; Magritte's italics)

From de Chirico onwards, time is a recurrent motif in Surrealist art. As the Belgian artist Marcel Broodthaers (1924–76) indicates in his short 'Imaginary Interview with René Magritte' (first published in 1967), Magritte himself owned several clocks in his Brussels home, which were all made to chime slightly out of synchronisation.

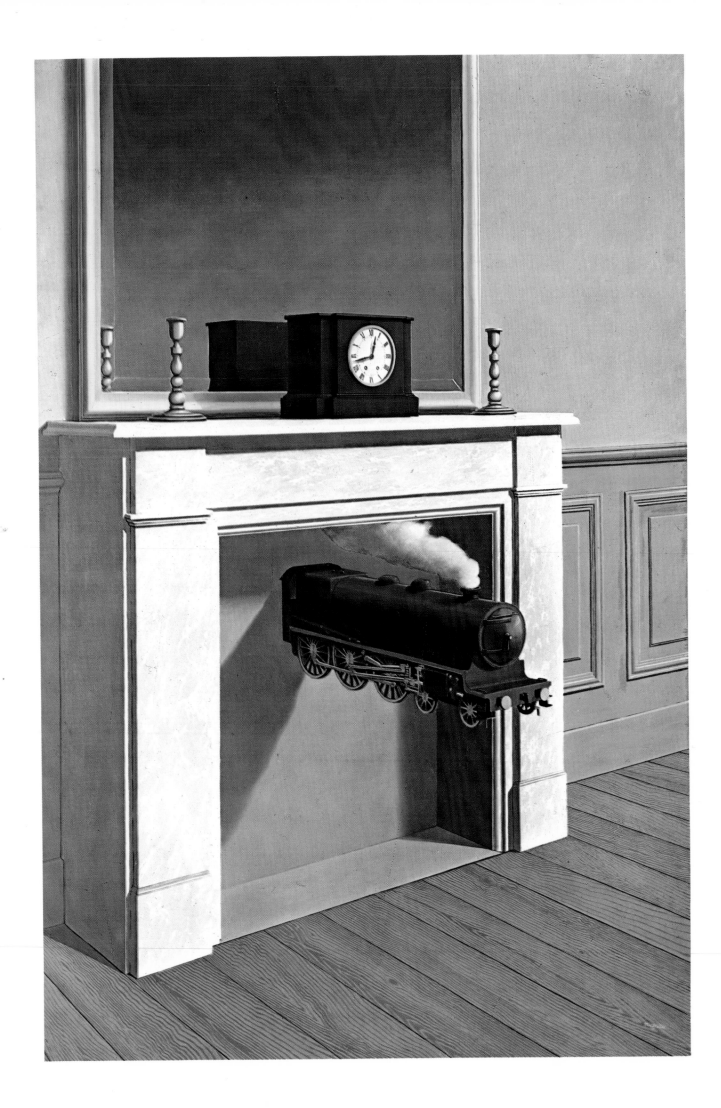

Memory/La mémoire

GOUACHE AND WATERCOLOUR ON PAPER, 35 × 26 CM. C.1942. PRIVATE COLLECTION

The antique marble or plaster head is a reminder of the classical world so dear to de Chirico (and, incidentally, a source of inspiration for many artists today).

Magritte actually made sculptures, usually from found objects such as plaster casts or empty bottles. *The Future of Statues* (Fig. 40) consists of a plaster cast of the death mask of Napoleon on which the artist has painted white clouds in a blue sky, thus 'transforming, in a totally unexpected manner, the face of death itself' (Paul Nougé, *René Magritte ou les Images Défendues*, 1943).

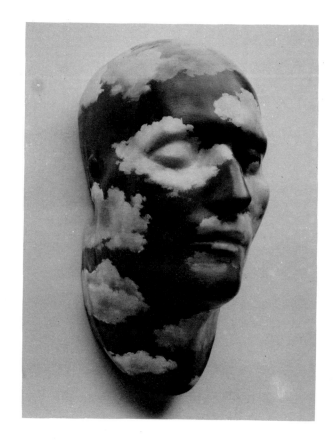

Fig. 40
The Future of Statues

OIL PAINTED PLASTER RELIEF, 33 × 16.5 × 20 CM. C.1937. LONDON,
TATE GALLERY

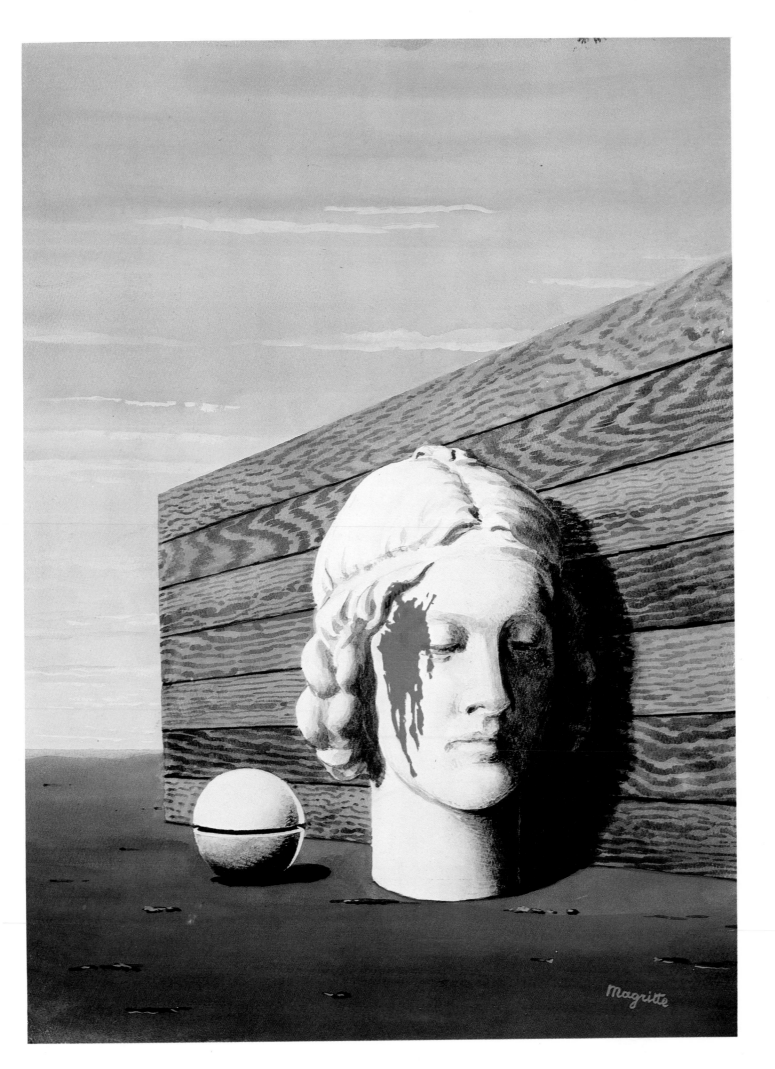

The Ocean/L'océan

OIL ON CANVAS, 50.5 × 65.5 CM. 1943. PRIVATE COLLECTION

In 1946 Magritte and some of his Belgian friends signed a manifesto, *Surrealism in Full Sunlight*, in which they rejected all that pre-war Surrealism had stood for: chance, automatism, black humour, displacement, ambiguity, fear. Instead of isolating objects from the material world and subjecting them to conditions of psychological stress, they proposed to reveal in a strong, radiant light unknown and invisible phenomena such as gods, phantoms, spirits and other benevolent forces; 'bewitching subjects', as Magritte described them, 'that will arouse what remains of our instinct for pleasure'.

Magritte's own work had been moving in this direction for three or four years. In his 'Renoir' pictures, colour assumes an independent, non-descriptive role. Impossible conjunctions of objects have given way to equally impossible and deliberately ironic colour combinations. The head, trunk and limbs of the nude figure in *The Treatise of Light* (Fig. 41) are all painted in different, chocolate-box colours.

Fig. 41
The Treatise of Light

OIL ON CANVAS, 55.2 × 75.3 CM. 1943. PRIVATE COLLECTION

The Pebble/Le galet

OIL ON CANVAS, 100 × 81 CM. 1948. PRIVATE COLLECTION

The Pebble and *The Pictorial Content* (Fig. 42) were both included in the exhibition of Magritte's *vache* pictures at the Galerie du Faubourg, Paris, in May 1948. Although the occasion was a disaster financially and critically, Magritte proved that he had lost none of the surrealist power to shock; even some of his former colleagues in the movement were appalled or baffled.

The 'impressionist' and *vache* styles, such as Fig. 43, suggest that Magritte was trying to forge a demotic pictorial language in opposition to non-representational art, and to the kind of art that relies on autobiographical symbols.

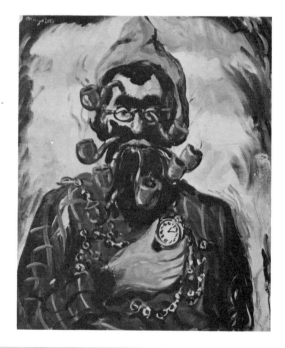

Fig. 42
The Pictorial Content

OIL ON CANVAS, 73 × 50 CM. 1947. BELGIUM, COLLECTION OF FRANZ
VERHOESTRAETE DE ROESELAERE

Fig. 43
The Cripple

OIL ON CANVAS, 60 × 50 CM. 1947. BRUSSELS, COLLECTION ISY
BRACHOT

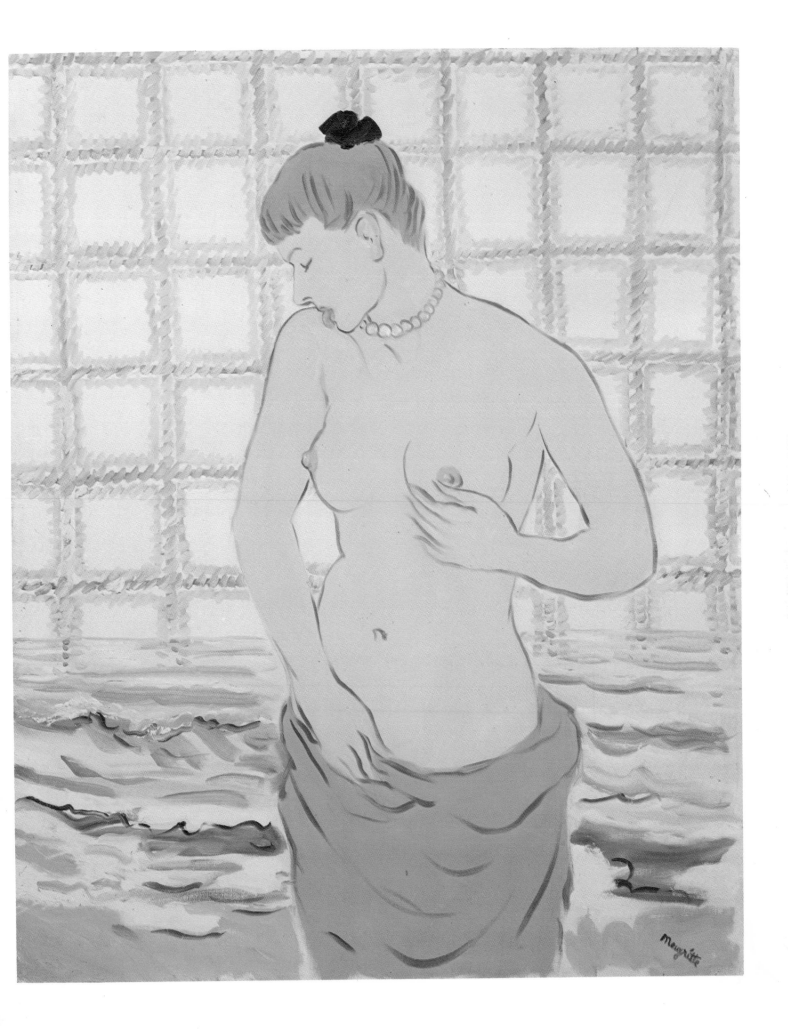

The Sorcerer/Le sorcier

OIL ON CANVAS, 34.8 × 45.3 CM. 1951. PRIVATE COLLECTION

This self-portrait shows Magritte in his role as magician, as the one who reveals the mystery of everyday reality. The image of a multi-limbed figure partaking of bread and wine also has clear religious associations, both Hindu and Christian. After his 'Renoir' and *vache* periods, Magritte never again experimented with any of the great stylistic innovations of late nineteenth- and twentieth-century art. At one time or another, he had been a Cubist, a Futurist, a Purist, an Impressionist and a Fauve (if the *vache* pictures are seen as a perversion of the latter idiom). Instead, he concentrated on what he believed to be painting's true aim: to represent, to make visible, perceived relationships in the world.

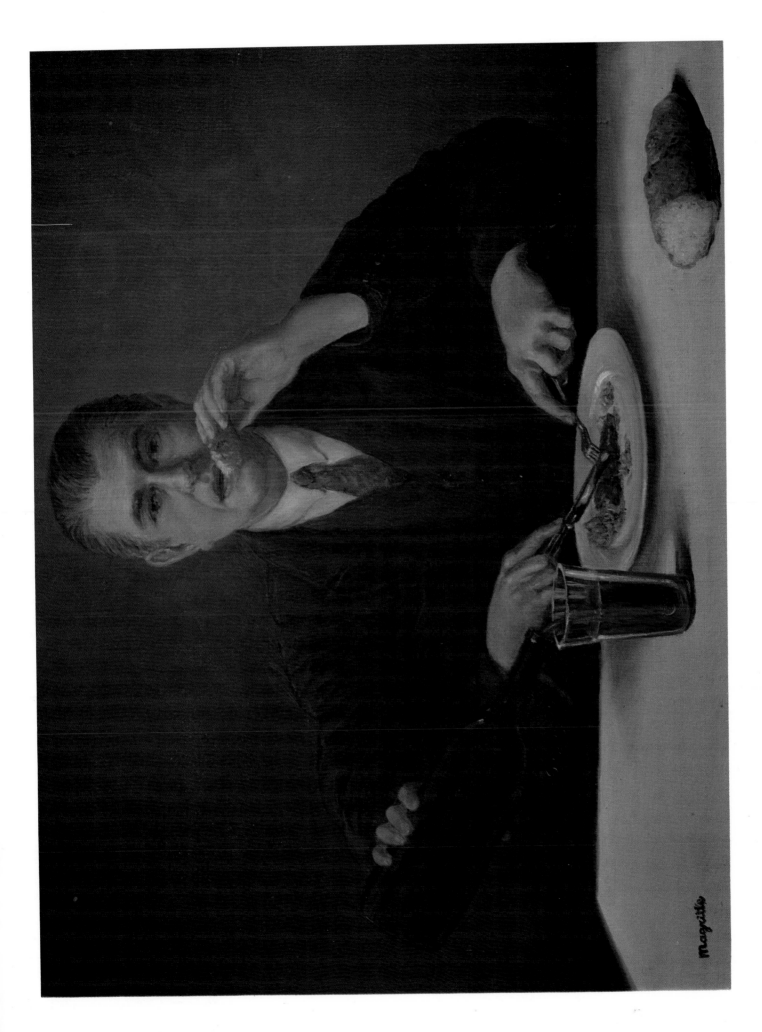

Magritte

The Song of the Violet/Le chant de la violette

OIL ON CANVAS, 99.5 × 81.3 CM. 1951. PRIVATE COLLECTION

The most terrifying of all Magritte's visions was of a world of utter silence in which humans and objects have turned to stone, as in some Absurdist play. The two men in this picture are placed in a rocky, lunar landscape against a background 'sky' resembling a stone wall, which greatly contributes to the feeling of claustrophobia.

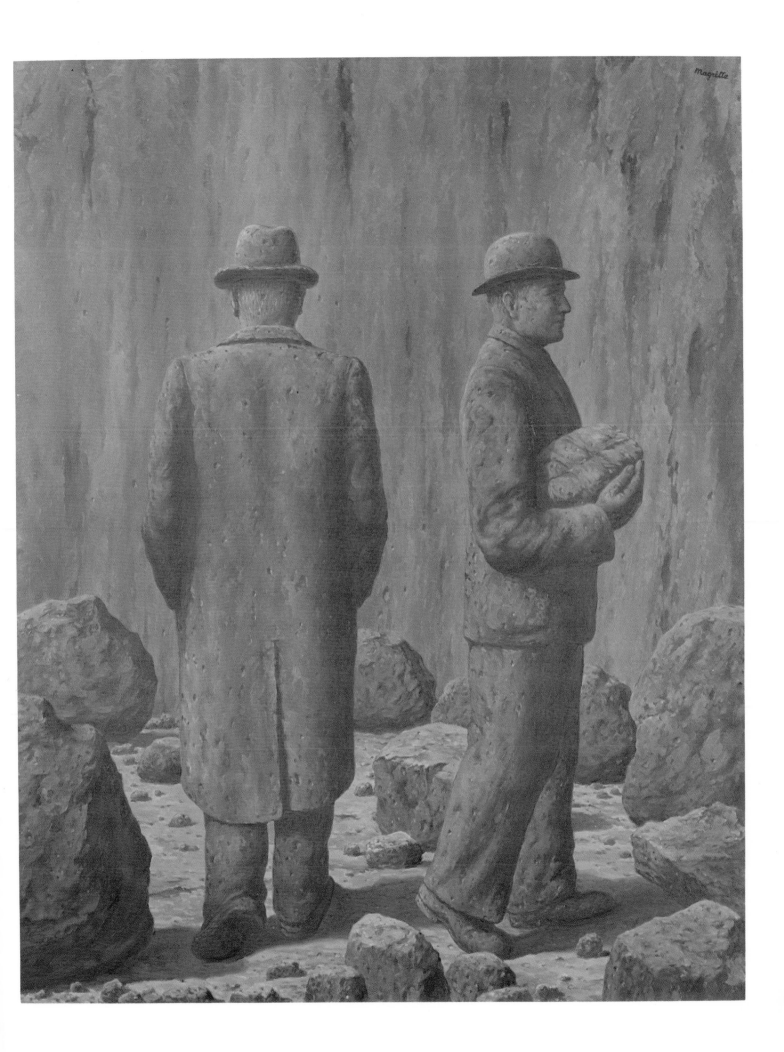

Personal Values/Les valeurs personnelles

OIL ON CANVAS, 80 × 100 CM. 1951–2. PRIVATE COLLECTION

'The only thing that engages me is the mystery of the world', wrote Magritte in 1957. In *Personal Values* and *The Listening Room* (Plate 47) the familiar is made to seem strange and threatening by a simple reversal of scale.

Magritte often makes clever use of the popular taste for *trompe l'oeil* decoration: his job in the wallpaper factory would probably have taught him how to simulate natural finishes such as marble and wood graining. The wall of the bedroom is 'papered' with a cloudy blue sky. Are we looking at the interior walls or the sky outside? It is deliberately ambiguous.

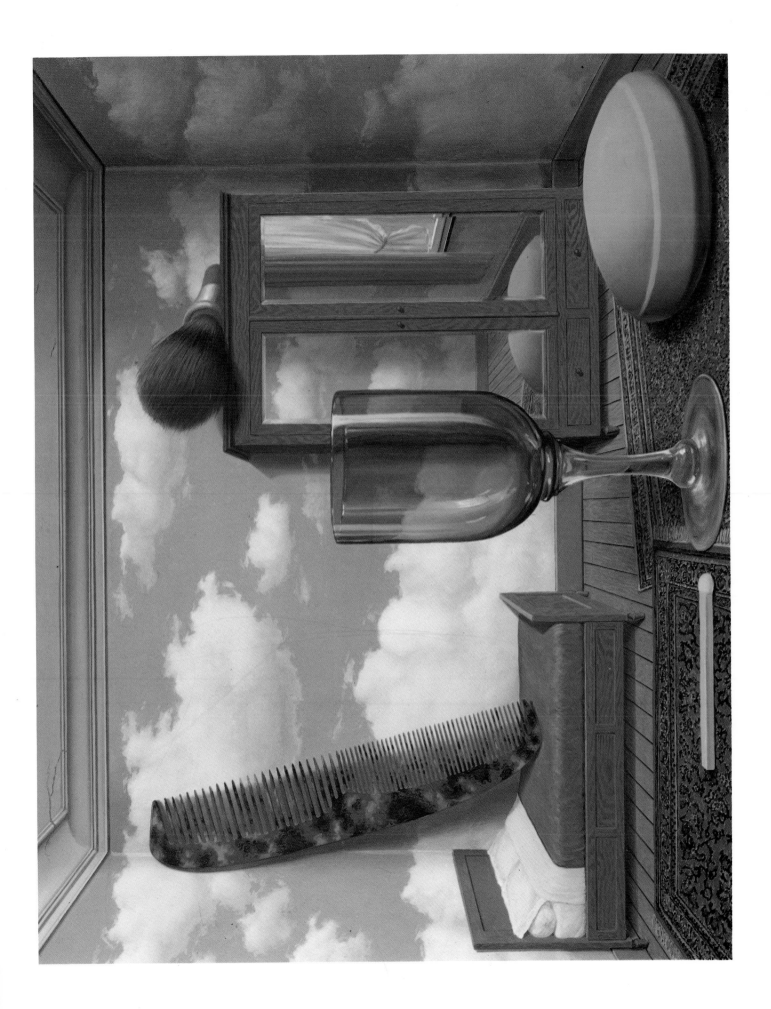

The Listening Room/La chambre d'écoute

OIL ON CANVAS, 45 × 54.7 CM. 1952. PRIVATE COLLECTION

This is one of Magritte's most disconcerting images. As with *Personal Values* (Plate 46), a feeling of claustrophobia, of near panic, is generated by the sight of objects behaving irrationally or adopting human characteristics. In 1956 Magritte wrote that 'for me, the conception of a picture is an idea of one thing or several things that can become visible through my painting'. These ideas were in the nature of speculations on the world.

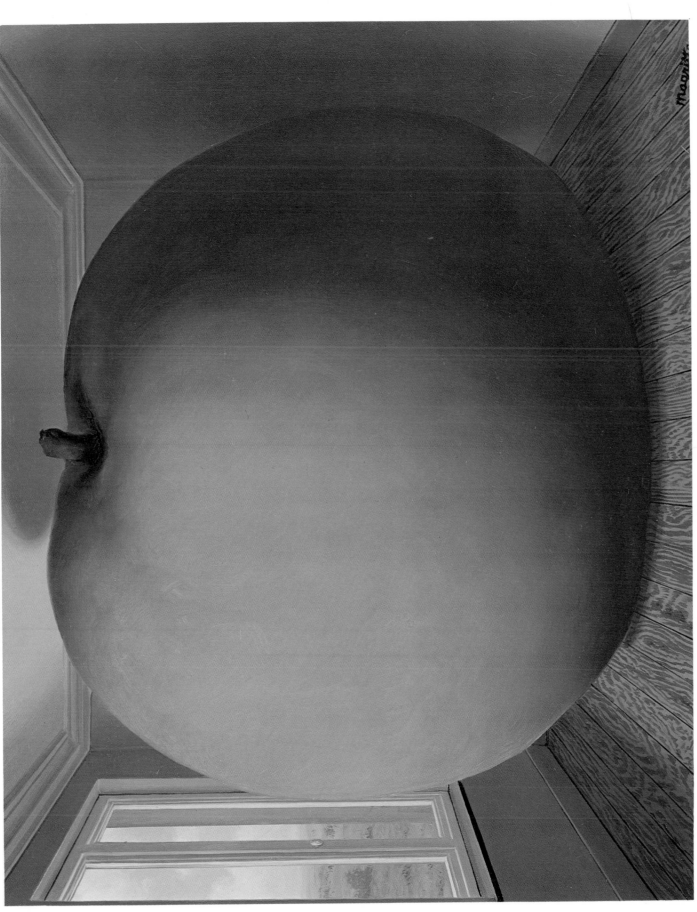

The Age of Enlightenment/Le siècle des lumières

OIL ON CANVAS, 50 × 40 CM. 1967. PRIVATE COLLECTION

Magritte once wrote that 'every object is mysterious'. If nothing else, his pictures, with their inconsistencies of scale, space and gravity, evoke a real sense of wonder. Free-floating parts of the face and body are sometimes used by fifteenth-century Flemish painters (for example, Rogier van der Weyden) to depict instruments of the Passion. Magritte would have been familiar with this convention from visiting the museum in Brussels. Balloons and other flying objects appear quite frequently in his pictures.

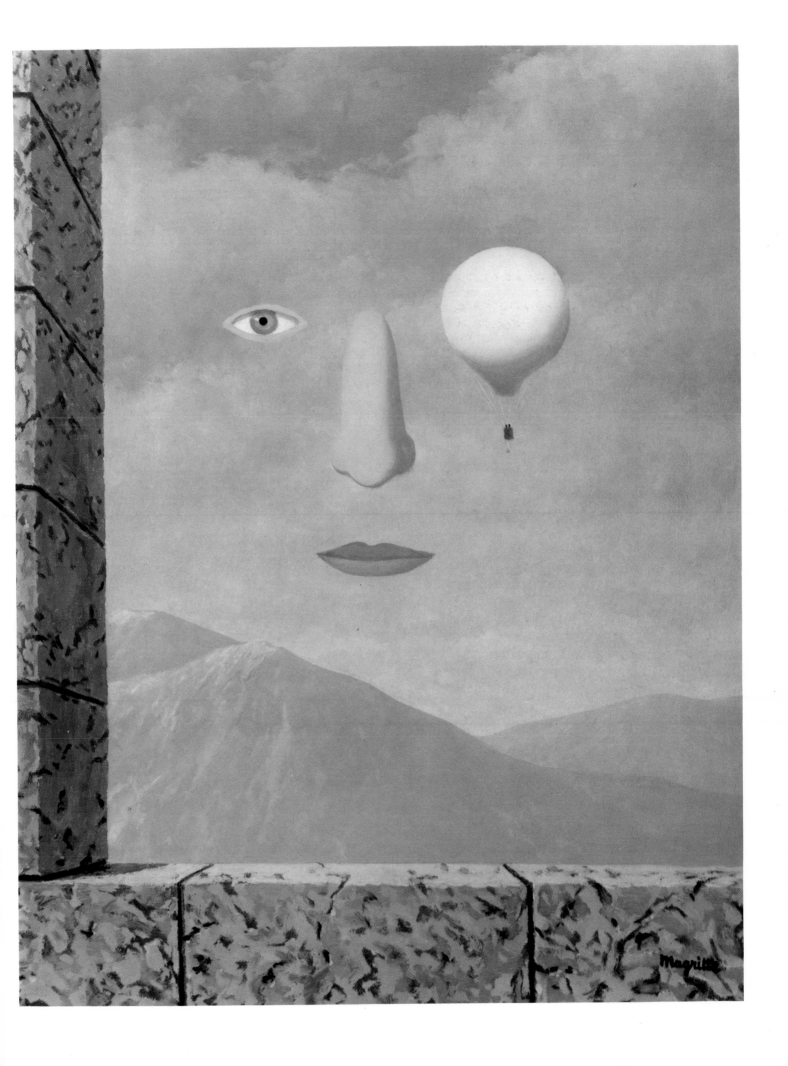